PHOTOGRAPH

MW01079602

# Cape Cod

## The Heart and Soul Beyond the Beach

Christopher Setterlund

AMERICA
THROUGH TIME®
ADDING COLOR TO AMERICAN HISTORY

America Through Time is an imprint of Fonthill Media LLC
www.through-time.com
office@through-time.com

Published by Arcadia Publishing by arrangement with Fonthill Media LLC
For all general information, please contact Arcadia Publishing:
Telephone: 843-853-2070
Fax: 843-853-0044
E-mail: sales@arcadiapublishing.com
For customer service and orders:
Toll-Free 1-888-313-2665

www.arcadiapublishing.com

First published 2023

Copyright © Christopher Setterlund 2023

ISBN 978-1-63499-425-5

Typeset in Gotham Book
Printed and bound in England

# Contents

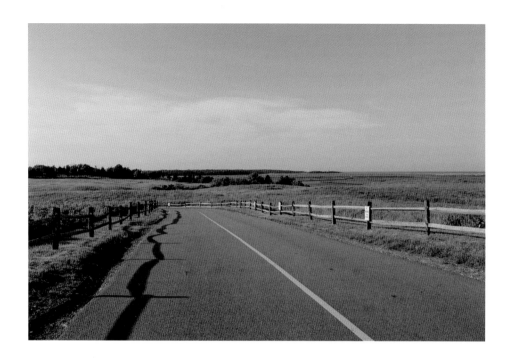

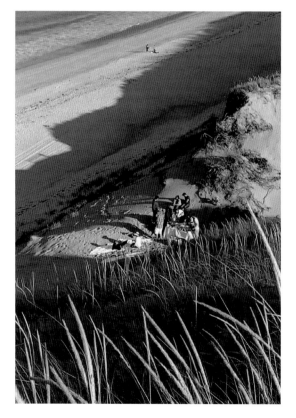

*Above:* The approach to Fort Hill in Eastham. A beautiful wide open view of Salt Pond Bay and Coast Guard Beach.

*Left:* A get together in the dunes at Longnook Beach in Truro.

# Acknowledgments

A special thanks to the two people that taught me more of what I know about photography than anyone: my high school photography teacher, Ronald Murphy, and one of oldest and closest friends, Steve Drozell. So much of this book is because of your teachings.

Nothing I have done in my life would have been possible or worthwhile without the love and support of my family. My mom, Laurie, who has always been my biggest supporter and even bought me one of my cameras. All four of my siblings—my sisters Kate, Lindsay, and Ashley, and my brother, Matt—who are my best friends. My six nieces and nephews: Kaleigh, Emma, Liam, Landon, Lucas, and Sylvie. My father, Serpa, Maui. All of my aunts, uncles, and cousins as well. Thank you all for supporting my journey.

I have been blessed to have so many great friends in my life as well. Barry and John, Crystal and Adam, Shayna, Deanna and Mike, Kaylin, Heather, Dr. Mike, Maggie, Dawn, Monique, Meghan and the Jones family, Emily Wood, and Bill Desousa-Mauk, without whom this book likely wouldn't have happened. Thank you all so much!

# Introduction

Since the latter stages of the nineteenth century, Cape Cod has been a vacation destination for generations. It has been, and still is, known for its hundreds of miles of pristine beaches. These beloved sandy sanctuaries carry names like Nauset, Craigville, Coast Guard, Sandy Neck, Race Point, and many more. Beyond the beautiful beaches of Cape Cod, however, there is so much more to see. These places comprise the heart and soul of a place many are lucky to call home and thousands flock to visit annually. Inside the pages of this book, many of these unique places of natural and historical significance will be showcased. There will be room to feature the well-known spots as well. Enjoy some beautiful photography of Cape Cod beyond just the beaches (although they are in here, too).

Looking toward Chatham Lighthouse from the Occupy South Beach Shack.

# 1. Welcome to Cape Cod

The Cape Cod Canal, opened in 1914, separates the peninsula from the rest of Massachusetts. There are three ways to cross the canal: the Sagamore Bridge, Bourne Bridge, and Railroad Bridge. Each of the current bridges are the second incarnations of said bridges with all three originals being drawbridges. The current bridges were built in the 1930s. The railroad bridge dates from 1933, while Sagamore and Bourne date to 1935.

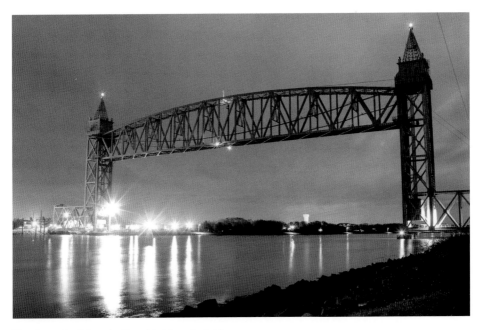

The Cape Cod Canal railroad bridge at night.

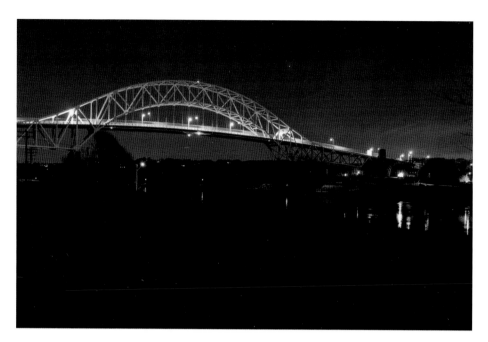

The Sagamore Bridge after dark.

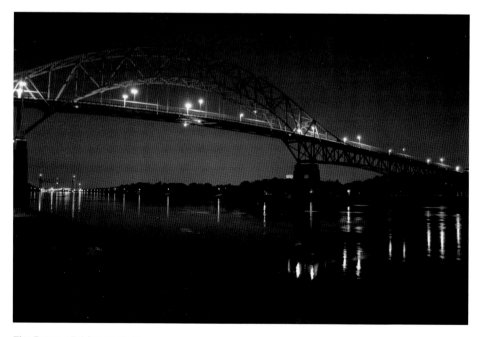

The Bourne Bridge at night.

# 2. Upper Cape

As the gateway to Cape Cod, it is here where one is first introduced to the beauty of the peninsula by crossing the Cape Cod Canal via one of three bridges. The Upper Cape includes the towns of Bourne, Falmouth, Sandwich, and Mashpee.

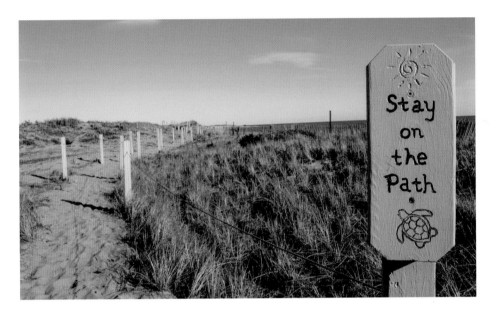

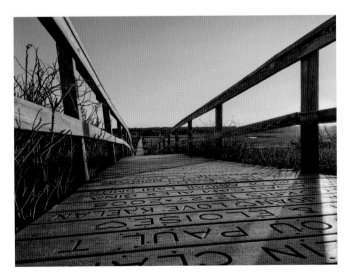

*Above:* Stay on the path to protect Cape Cod's fragile dunes.

*Left:* Sunset at the Sandwich Boardwalk.

### Wings Neck Light: 1 Lighthouse Ln., Pocasset

This wooden beacon at the tip of Wings Neck was built in 1849. Overlooking Buzzards Bay, it was deactivated in 1945 after the construction of Cleveland Ledge Lighthouse just over two miles off shore. The lighthouse and three-bedroom keeper's house are today an elegant bed and breakfast available for rent via Airbnb.

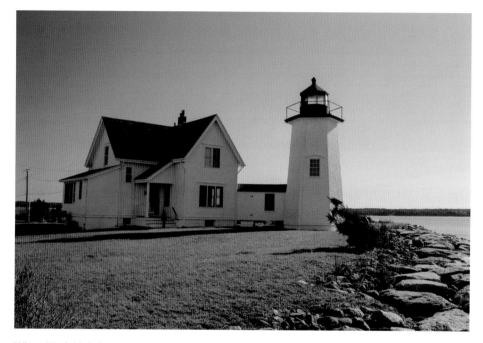

Wings Neck Lighthouse, now an Airbnb, in Pocasset.

### Aptucxet Trading Post: 6 Aptucxet Rd., Bourne (*opposite*)

Nestled along the Cape Cod Canal is a 12-acre museum. The highlight is a replica of the first Plymouth Colony trading post that was established in 1627. However, there is much more including the windmill owned by nineteenth-century actor Joseph Jefferson. In addition, there is a replica salt works and gift shop.

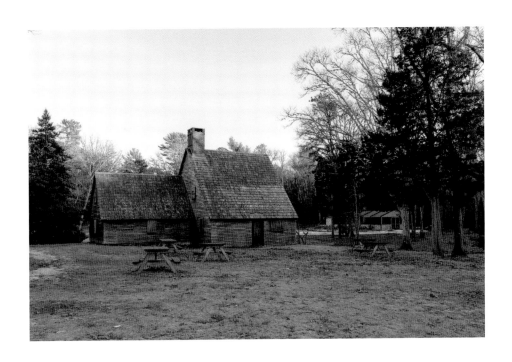

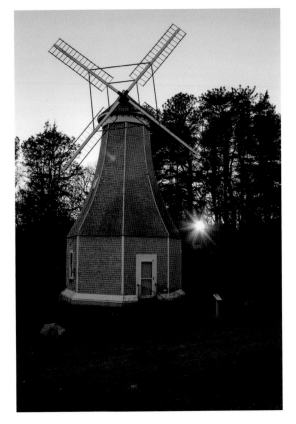

*Above:* The Aptucxet Trading Post in Bourne.

*Left:* The sunset behind Joseph Jefferson's windmill at Aptucxet.

### Gray Gables Railroad Station: 6 Aptucxet Rd., Bourne

The railroad station formerly used by President Grover Cleveland—beginning during his second term in office in 1893, when Bourne was home to the summer White House—is a part of the Museums at Aptucxet. In 1976, it was moved from its original site, a mile west, to the museum grounds. At the original site is a marker denoting the former presence of the railroad station.

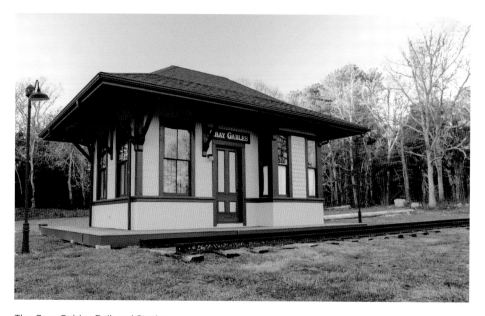

The Gray Gables Railroad Station.

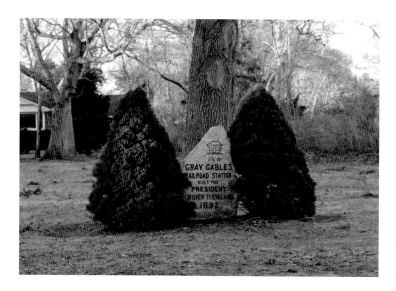

The original site of the Gray Gables Railroad Station.

## Mashnee Island, Bourne

A former island, Mashnee is now connected to the mainland thanks to dredge spoils from Cape Cod Canal improvements in the 1930s. The manmade causeway leads to a neighborhood of approximately 140 houses.

The causeway to Mashnee Island in Bourne.

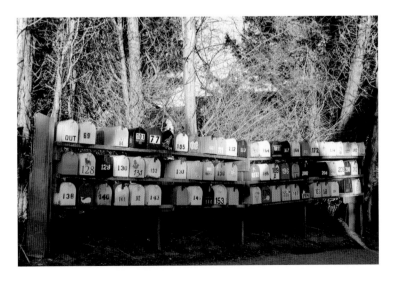

Mashnee Island's collection of mailboxes.

## The Knob: Quissett Harbor Rd., Falmouth

A natural rock outcropping that is hugely popular and yet also underrated, this beloved sunset and wedding photography spot sits about a 1/3-mile walk from the parking lot at Quissett Harbor. The land surrounding The Knob was donated to the Salt Pond Area Bird Sanctuaries by Cornelia Carey upon her death in 1973.

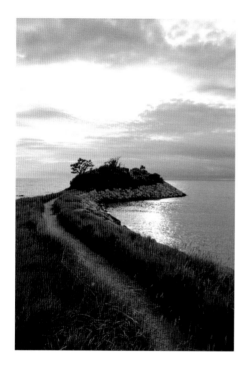

A beautiful path to The Knob in Falmouth.

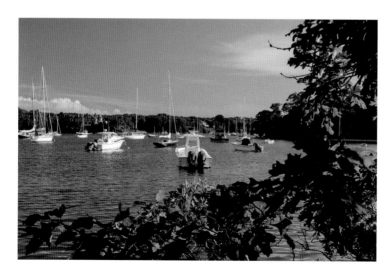

The boats at Quissett Harbor in Falmouth.

## Nobska Light: 233 Nobska Rd., Woods Hole

This light station was first established in 1829 with the current beacon built in 1876. Prior to that, Nobska Point was home to a smallpox hospital established by Dr. Francis Wicks from 1797–1802. The grounds are open to the public and provide sweeping views of Martha's Vineyard and the Elizabeth Islands.

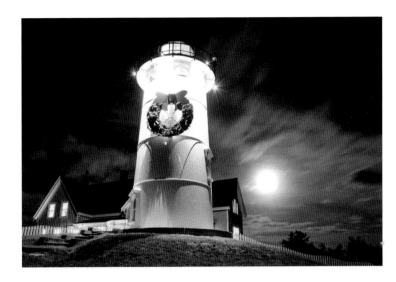

A long-exposure shot of Nobska Lighthouse after dark.

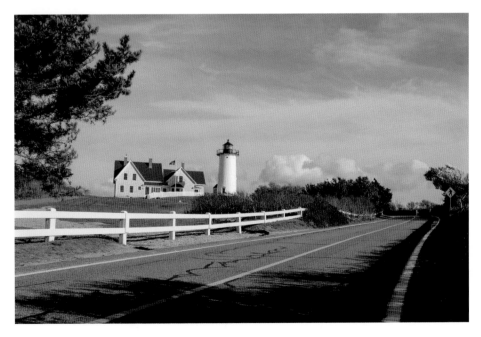

Nobska Road approaching Nobska Lighthouse.

### Highfield Hall & Gardens: 56 Highfield Dr., Falmouth

This 1878 Victorian mansion is surrounded by 400 acres of conservation land. It was originally built by the Beebe Family. The grounds feature seasonal art exhibits, meticulously manicured gardens including a beautiful sunken garden, and numerous trails through Beebe Woods. The building was completely restored in the early 2000s.

Highfield Hall in Falmouth.

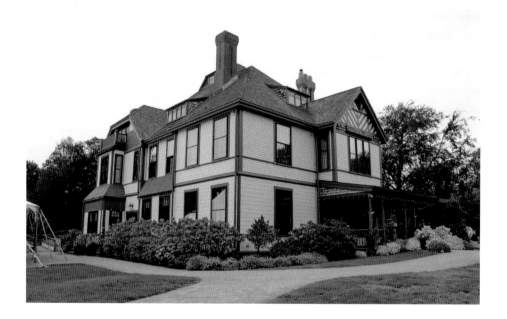

### Bourne Farm: 6 North Falmouth Highway, North Falmouth (*opposite above*)

More than forty-nine acres of fields and trails make up this underrated Cape Cod attraction. Whether gazing upon neighboring Crocker Pond or walking out to the old cattle tunnel that travels underneath the bike trail, there is no shortage of unique views. The main house is often used for weddings, receptions, and other functions.

### River Bend Conservation Area: 682 Sandwich Rd., East Falmouth (*opposite below*)

This 10-acre parcel of land was at one point part of Sunnyside Farm in the early twentieth century. The ceramic silo, likely the only one on Cape Cod, adds a unique touch to the entrance of the property. The paths allow you to see vernal pools, overgrown cranberry bogs, a freshwater marsh, and more.

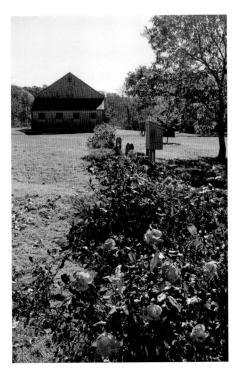

Summer at Bourne Farm.

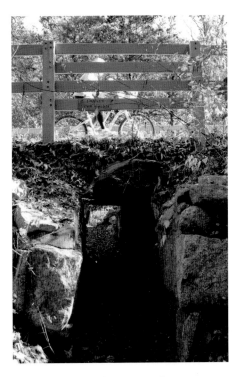

An old cattle tunnel at Bourne Farm.

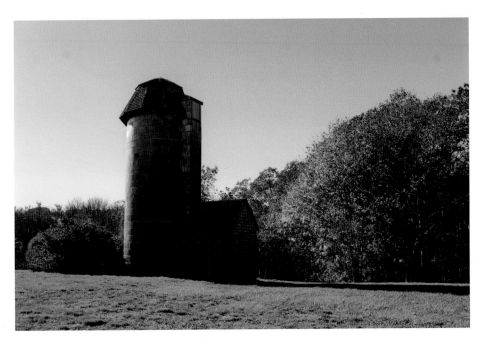

A ceramic silo at River Bend Conservation Area.

## Falmouth Main Street

A classic Main Street, filled with restaurants and shops. Beautifully green in summer and perfectly serene in winter, this stretch of town is always filled with people and vehicles even in the depths of winter. Beyond food and gifts this Main Street has deep connections to Falmouth's history. This includes a life-sized statue of "America the Beautiful" writer and Falmouth native Katharine Lee Bates, as well as eleven bronze plaques created by artist Sarah Peters that are part of the sidewalk. They display many of the industries that helped to build Falmouth.

*Above:* A wide view of Falmouth's Main Street.

*Left:* A statue of Katharine Lee Bates at the Falmouth Library.

## Falmouth Road Race Finish Line: Grand Ave., Falmouth

Cape Cod's most well-known road race finishes here among the beautiful sights of Falmouth Heights. The race was founded in 1973 by Tommy Leonard and traced the roughly 7-mile route between a pair of bars, Captain Kidd in Woods Hole, and Brothers 4 in Falmouth. From its humble beginnings, this annual event has grown so popular that it routinely sees more than 10,000 runners take part.

The Falmouth Road Race finish line.

## South Cape Beach State Park: 668 Great Oak Rd., Mashpee

A rural oasis tucked away in Mashpee there is hiking, swimming, and lots to see over more than 400 acres of land. It is abutted to the west by the 852-acre Waquoit Bay and contains miles of walking trails over sand and through marshlands and uplands.

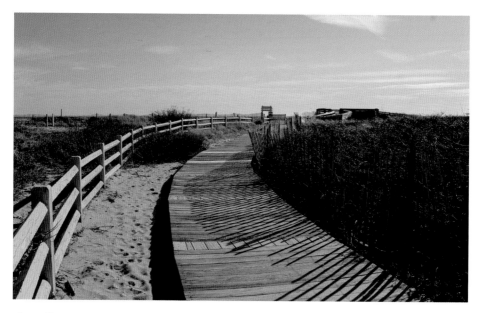

The walkway to South Cape Beach in Mashpee.

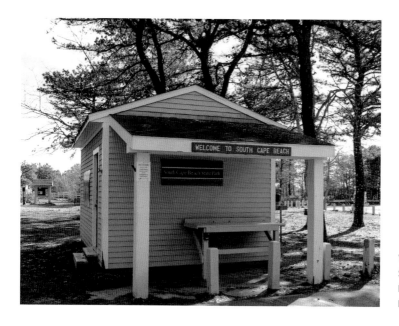

Welcome to South Cape Beach in Mashpee.

# 3. Mid-Cape

The center of Cape Cod, this can also be considered the unofficial business hub of the peninsula thanks to the countless shopping centers and restaurants located in Hyannis. The Mid-Cape includes the towns of Barnstable, Yarmouth, Dennis, and Harwich.

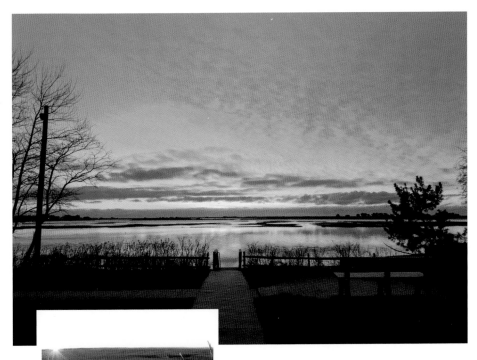

*Above:* Sunrise over Bass River in Yarmouth.

*Left:* Some Kindness Rocks at sunset.

## Snowy Road to Sesuit Harbor: East Dennis

Though it is quite the popular summer destination, Cape Cod is every bit as beautiful under a blanket of snow. It might take a little longer to drive safely through the wintry white, but the sights hearken back to a simpler time.

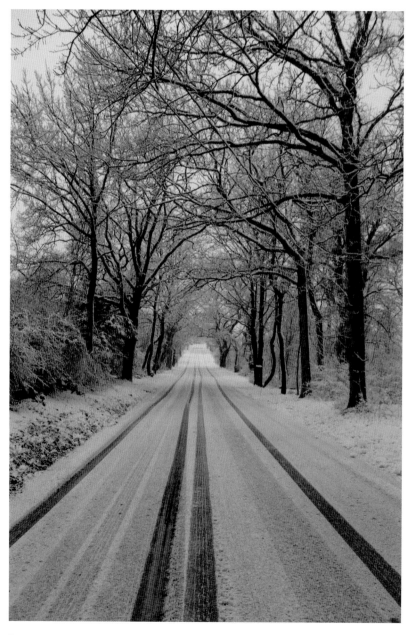

Snowy trees acting as a canopy over the road to Sesuit Harbor in Dennis.

## Wequassett Resort & Golf Club: 2173 Route 28, Harwich

Wequassett is the only Five-Star luxury resort on Cape Cod. Made up of twenty-two buildings, the complex started out modestly in 1925. Original owners, Carroll Nickerson and his wife, Emogen, had only an oilcloth sign and word of mouth for advertising. It first achieved its five-star resort status, according to Forbes Travel Guide, in 2016. One visit will show why it is one of only 199 five-star resorts in the world.

The Square Top house at the Wequassett Resort.

## Long Beach: Long Beach Rd., Centerville (*on the next page*)

Though technically the same stretch of sand as Craigville Beach, this pristine barrier beach reaches all the way into Osterville. At the tip it faces Dowses Beach. The Herring River and Bumps River empty into East Bay on the north side of Long Beach. It is both isolated and well within sight of many homes. This mile-long beach was once home to a beautifully decorated shell tree. Sadly, it has since been destroyed.

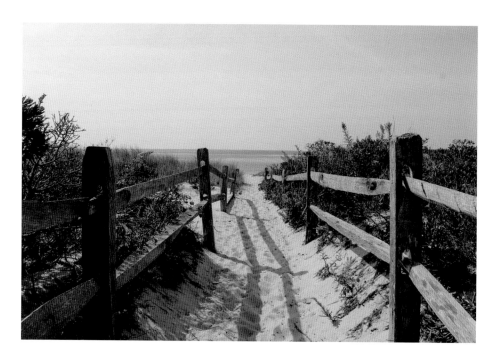

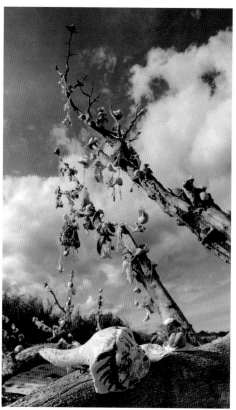

*Above:* The path to Long Beach in Centerville.

*Left:* The now-destroyed shell tree from Long Beach.

## Whale Watch Boat Barnstable

Whale watching is a popular tourist activity during the summer months on Cape Cod. There are several reputable companies running all over the peninsula. On these excursions it is possible to see such species of whale as Humpback, Finback, Minke, Pilot, and Right. This boat belongs to Hyannis Whale Watcher Cruises.

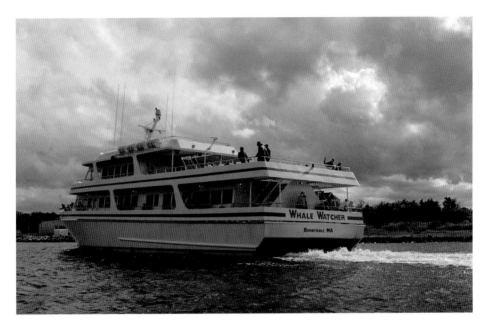

A whale watching boat returning to Barnstable Harbor.

## Sandy Neck Lighthouse and Colony: West Barnstable
(*on the next page*)

The history of this collection of cottages goes back more than three centuries. In 1703, most of Sandy Neck was divided into sixty private parcels of land. Lot #60, at the tip of Sandy Neck, became the site of a summer cottage community. As of 2022, there are fifty-eight cottages along Sandy Neck. The lighthouse was first lit in 1826. It was decommissioned in 1932 and its lantern was removed. Sandy Neck Light remained "headless" until 2007 when it was restored to full working order. The beach to the east and north of the colony is public, but the cottages themselves are private property.

The Sandy Neck Colony and lighthouse.

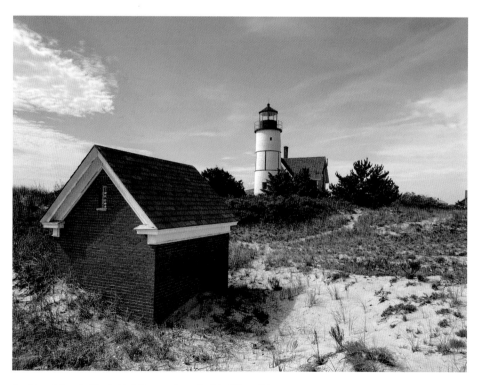

A view of Sandy Neck Lighthouse from behind the oil house.

### St Mary's Episcopal Church: 3055 Main St., Barnstable

In the heart of Barnstable Village is this oasis. Located behind the church is a beautiful flowery walkway and garden. It was established in 1946 by Reverend Robert Wood Nicholson. The church is all-inclusive, and the gardens are an inviting respite from the world. In addition to the blooming wildflowers, one can see chipmunks, frogs, numerous bumblebees, and countless birds, like this dove.

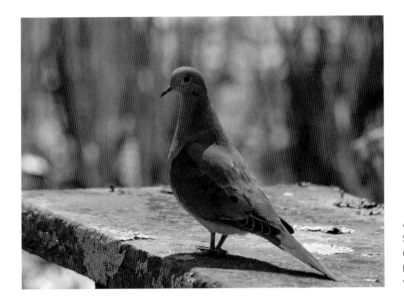

A dove at St. Mary's Church in Barnstable Village.

Cherry blossoms at St. Mary's Church.

## Wizard of Oz Display at the Palaemon House:
## 3401 Main St., Barnstable

This seasonal display tends to turn the heads of those passing by on Route 6A. Typically reserved for Halloween, the pumpkin-head versions of Dorothy, Scarecrow, Tin Man, and Cowardly Lion reflected the state of the world for their most recent appearance. The display is on the property of the nonprofit Palaemon House, so be respectful if stopping to take photos.

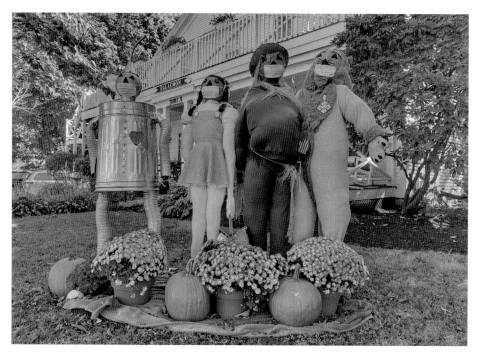

The Wizard of Oz display at the Palaemon House.

## HyArts Artist Shanties: Ocean St., Hyannis

These popular artist shacks are in two locations along Ocean Street: Bismore Park and Harbor Overlook. The seven at Bismore Park were built in 2005 and are named for each of the seven villages of the Town of Barnstable. Though frequented by artists during the summer, the shanties are there year-round. They are festively decorated during the Holiday season.

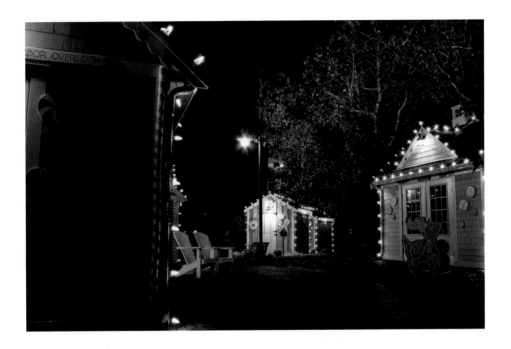

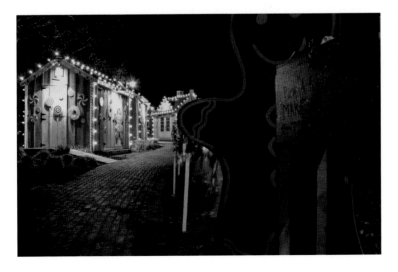

The HyArts artist shanties decorated for the Holidays.

### 1856 Country Store: 555 Main St., Centerville

This general store is a throwback to simpler times. From toys, novelties, Penny Candy, and more, it's more of a destination than a simple store. The building dates to 1840 when it was used to store cranberries. It became a general store in 1856 and has been so ever since.

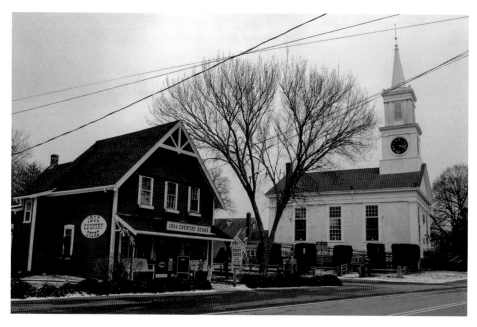

A wide view of the historic 1856 Country Store and South Congregational Church in Centerville.

### Oyster Harbors: Bridge St., Osterville (*opposite above*)

A private, gated community within Osterville, this is one of the most exclusive neighborhoods on Cape Cod. The windmill at the gates is a century old.

### Samuel Dottridge House: 1148 Main St., Cotuit (*opposite below*)

It is now the home of the Cotuit-Santuit Historical Society. For decades, it was a part of a popular resort hotel known as The Pines. Before that, it was the home of carpenter, Samuel Dottridge. The home was actually pulled by oxen to its current location from Brewster in the first decades of the nineteenth century. A tremendous hotel compound was built all around it and then torn back down. This house outlasted it all.

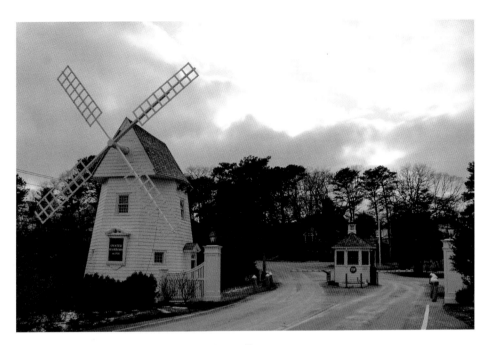

The gated entrance to Oyster Harbors in Osterville.

The Samuel Dottridge House in Cotuit.

## Taylor-Bray Farm: 108 Bray Farm Rd. N, Yarmouth Port

Tucked away on the north side of Yarmouth Port is this charming small farm. Begun by the Taylor Family in the 1640s and taken over by the Bray Family in 1896, this spot has no shortage of great photo opportunities. From a sunset over the marsh, sheep, goats, and Scottish cattle, to even a simple friendly scarecrow, all one has to do is walk the grounds and let the scenes unfold.

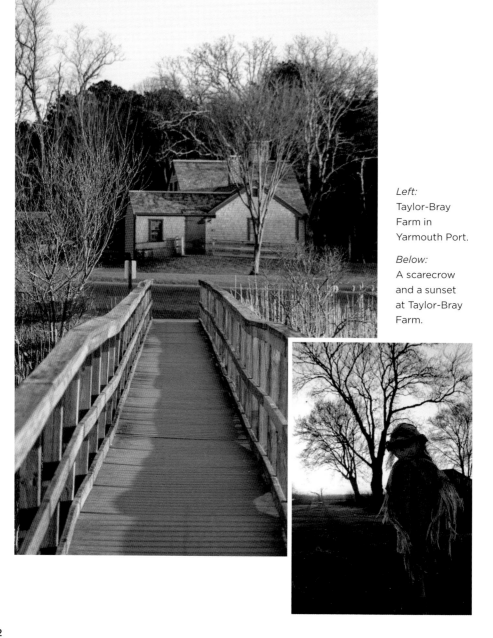

*Left:*
Taylor-Bray Farm in Yarmouth Port.

*Below:*
A scarecrow and a sunset at Taylor-Bray Farm.

## Seagull Beach in winter: Sea Gull Rd., West Yarmouth

Though one thinks of visiting the beach as a summer activity, there are plenty of great photo opportunities for those who dare to visit in the peak of the cold and snow of winter. It is bordered to the east by Parker's River and to the west by the private community of Great Island. Each step in between is filled with pristine scenery.

A snowy walk to the beach at Sea Gull Beach.

## Gray's Beach/Bass Hole: Center St., Yarmouth Port

The boardwalk that stretches out over the Center Street Marsh has become an iconic Cape Cod location. The beach itself is small, but there are many trails leading through the surrounding uplands. For many, though, it is the boardwalk, with its engraved planks and spectacular sunset viewing opportunities, that attracts a full parking lot of people most nights, even in the cold of winter.

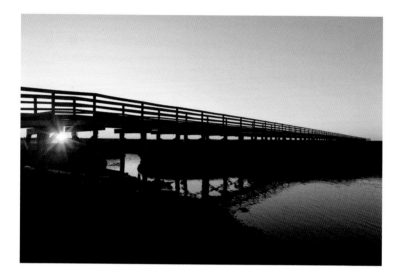

*Left:* Sunset at Bass Hole in Yarmouth Port.

*Below:* People watching the sunset from the boardwalk at Bass Hole.

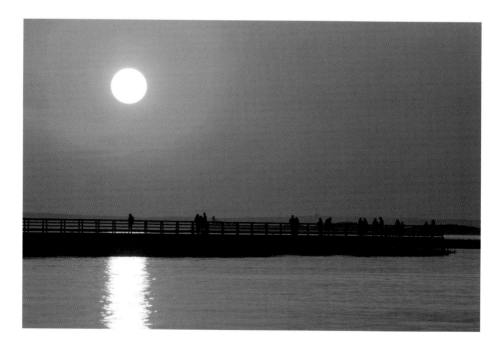

**First Traffic Circle: River & Pleasant St., South Yarmouth**
This unassuming brick-based structure is the first rotary in
America. Originally a watering trough, Charles Henry Davis
transformed it into signage that helped handle traffic in the area
shortly after moving to town in 1902.

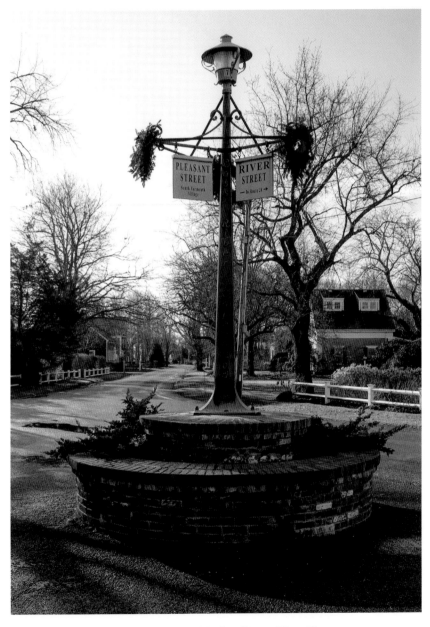

The first traffic circle in America located in the village of Bass River.

# 4. Lower Cape

Being that Cape Cod is roughly shaped like an arm, this area represents the elbow. The collection of towns noted for beautiful seaside resorts includes the towns of Brewster, Orleans, and Chatham.

*Left:* Chatham's Lighthouse Beach.

*Below:* The expansive uplands at Harding's Beach.

**Gulls at Herring Run: 830 Stony Brook Rd., Brewster**

Every spring, young alewives, more commonly known as herring, migrate to spawn. The series of sloops built into this stream help these fish on their way. Another tradition of the springtime rush of herring is the flock of gulls that surround the waters looking for a quick meal. This spot is a perfect family activity.

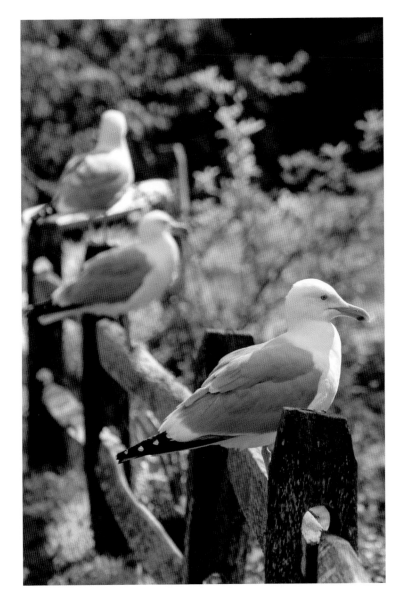

Herring gulls waiting for a meal at the Stony Brook herring run.

## Stony Brook Grist Mill: 830 Stony Brook Rd., Brewster

This water-powered grist mill is a popular photography spot in all seasons. It is still possible to purchase freshly ground corn meal at this historic site. The mill is all that is left from Brewster's nineteenth-century industrial Factory Village. One cannot visit the grist mill without taking a walk across the street to the herring run as well.

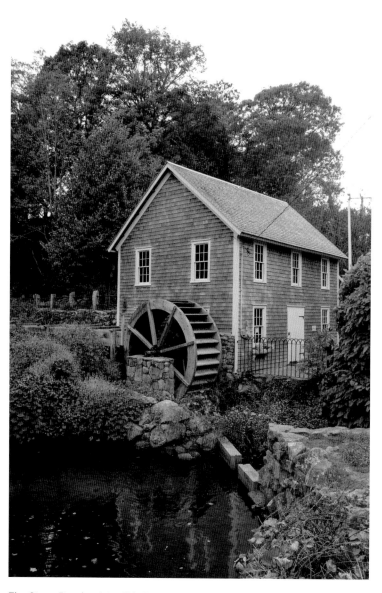

The Stony Brook grist mill in Brewster.

## Ocean Edge Resort & Golf Club: 2907 Main Street, Brewster

This entire property was once owned by the Nickerson Family. The current Nickerson Mansion was built in 1907 after the previous one named Fieldstone Hall burned down. For decades the property was home to the LaSalette Seminary. The Ocean Edge Resort opened in 1981 and today includes a golf club, spa, private beach, restaurants, and private villas. The front lawn, restaurants, and bar are open to the public.

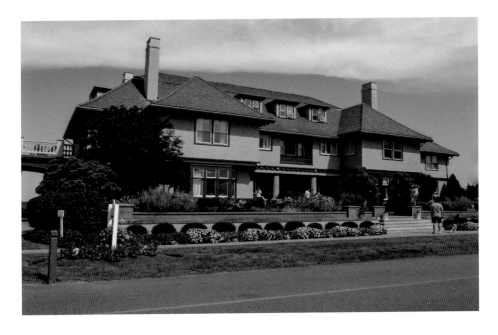

*Above:*
The Nickerson Mansion at Ocean Edge in Brewster.

*Below:*
The Ocean Edge Beach Bar in Brewster.

### Crosby Mansion: 163 Crosby Ln., Brewster

This elegant, yellow home is only a stone's throw from the beach bearing the Crosby name. A throwback to Chicago's Gold Coast mansions, it was completed in 1888. Named "Tawasentha" by its owner, Albert Crosby, the three-story, thirty-five room mansion remained in the family for nearly fifty years. It passed through several hands before finally being purchased by the state in the late 1970s. For over twenty-five years, the Friends of Crosby Mansion has restored the mansion to its former glory thanks to income from tours and weddings held there.

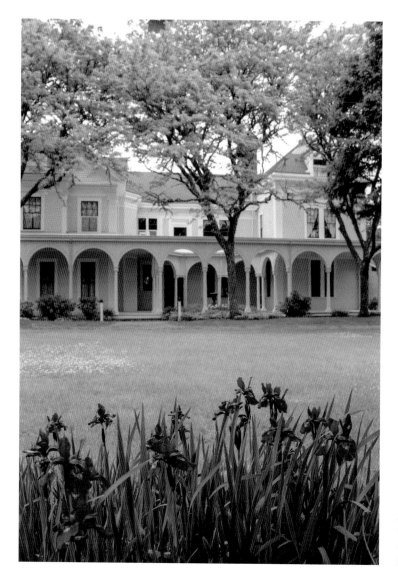

Across the lawn from the Crosby Mansion in Brewster.

## Stage Harbor Light: Harding's Beach Rd., Chatham

Hidden in plain sight is this beacon seated at the end of Harding's Beach. This lighthouse was built in 1880 at the entrance to Stage Harbor. It was deactivated in 1933, with its lantern being removed. It is now privately owned but can be viewed from outside of the property limits.

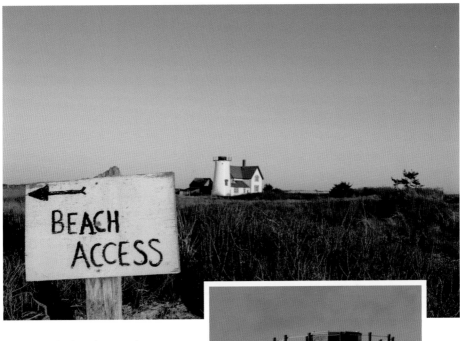

*Above:* To the beach, or to the lighthouse?

*Right:* Stage Harbor Lighthouse in Chatham which does not have a lantern.

## Samuel de Champlain marker—near 576 Stage Harbor Rd., Chatham

Hidden among tall reeds within sight of the Stage Harbor Yacht Club, this marker commemorates a pair of visits to Cape Cod by the famed French explorer. In 1605 and 1606, Champlain landed on the Cape shores. In 1605, he docked near the Salt Pond Visitors Center in Eastham. The second time, Champlain docked near where the plaque stands and explored Chatham for ten days.

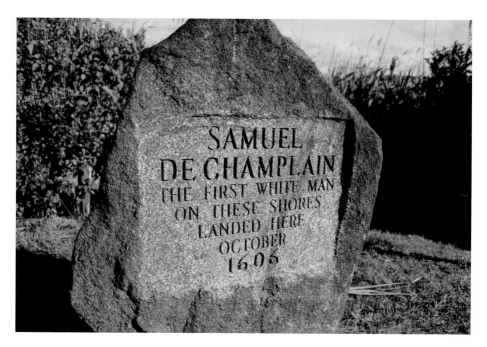

The Samuel de Champlain marker in Chatham.

## Chase Park: Cross St., Chatham (*Opposite*)

A hidden gem with much to see, the historic Godfrey Windmill, built in 1797, is one of Massachusetts' few wooden windmills still standing. Perhaps most unique in the park is the Chatham Labyrinth. Its design is a replica of the eleven-circuit medieval labyrinth found in the floor of Chartres Cathedral in Chartres, France.

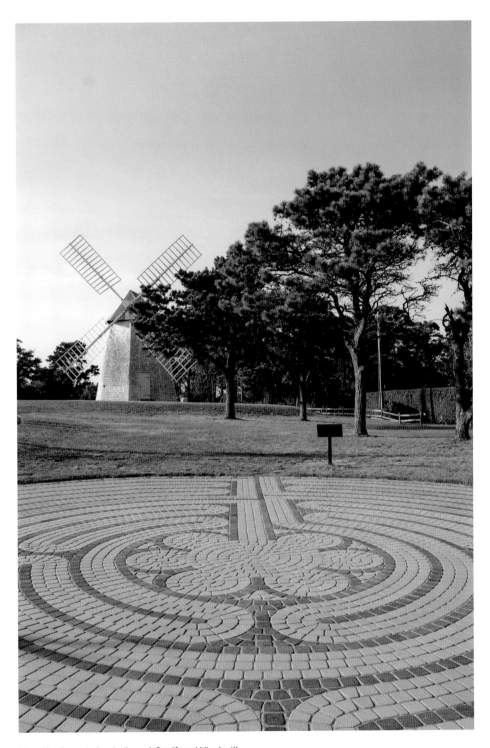

The Chatham Labyrinth and Godfrey Windmill.

## Chatham Bars Inn – 297 Shore Rd. Chatham

Since 1914, this resort hotel has been catering to visitors and locals interested in a staycation. It was originally founded by Charles Ashley Hardy, who wished to create a totally self-sufficient luxury hotel. In 2021, *Conde Nast Traveler* named Chatham Bars Inn one of the forty-five best resort/hotels in the world. It boasts 217 rooms and suites, an eight-acre farm in Brewster, four public restaurants, and more than a century of experience in creating a perfect experience for its guests.

 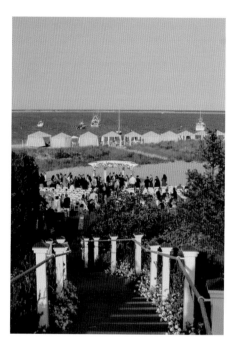

*Left:* Looking out from the front steps of Chatham Bars Inn.

*Right:* A wedding on the beach at Chatham Bars Inn.

## Chatham Lighthouse/Lighthouse Beach: 37 Main St., Chatham
(*Opposite*)

Originally part of a set of twin lighthouses, this beacon overlooks North Beach Island and neighboring Lighthouse Beach. The current tower was built in 1877 with its twin now known as Nauset Lighthouse in Eastham after being moved in 1923. At 48-feet tall, it provides tremendous vantage points and is typically open for tours during the summer. A short walk over the sand of Lighthouse Beach brings one face to face with a unique and rustic shack. Known as the Occupy Chatham South Beach Shack, it was erected in 2015.

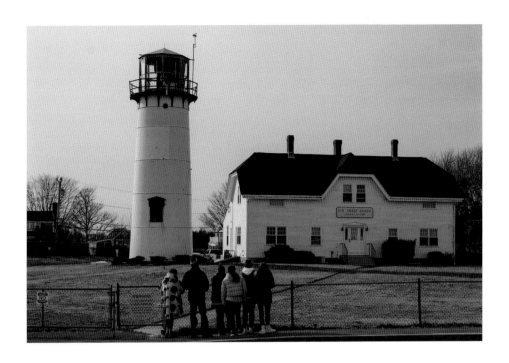

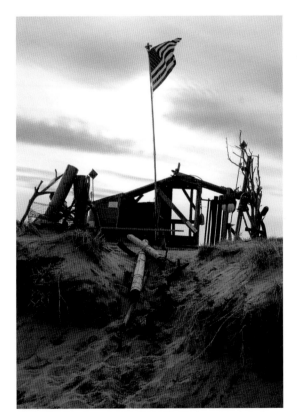

*Above:* A group of people visiting Chatham Lighthouse.

*Left:* The Occupy South Beach dune shack on Lighthouse Beach in Chatham.

## Nauset Beach – Beach Rd., Orleans

Located in Orleans, it is one of the most popular beaches on Cape Cod. The main beach is routinely filled with people on the sand and surfers in the water. For those looking for a private slice of Nauset, there is an ORV trail system. Five total trails lead vehicles more than five miles south to the entrance to Pleasant Bay. Those looking for buried treasure need only walk two miles south form the main parking lot. There, if lucky, one might be able to spot the remains of the Montclair. This was a 142-foot three-masted schooner that wrecked in the area in 1927.

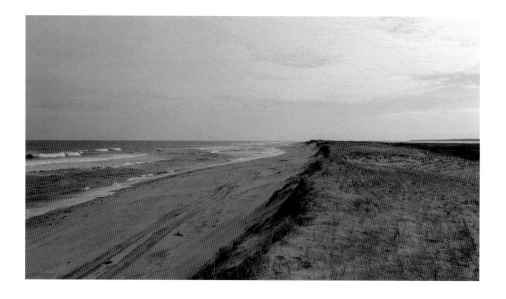

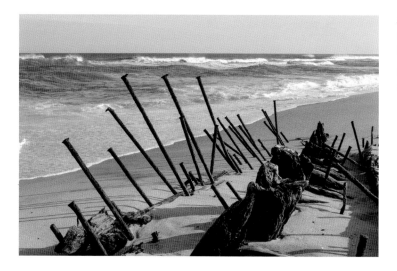

*Above:* Looking south at Nauset Beach.

*Left:* The wreck of the Montclair.

## Lifeboat CG36500: Bay View Dr., Orleans

This piece of maritime history resides at Rock Harbor in Orleans during the summer months. It was used to rescue the crew of the tanker Pendleton off Chatham in 1952. The 36-foot wooden motor lifeboat was built in 1946 in Maryland. It was retired from service in 1968 and sat for years before being purchased by the Orleans Historical Society in 1981. The vessel and the Pendleton rescue were brought to life in the 2009 book and 2016 film, *The Finest Hours*.

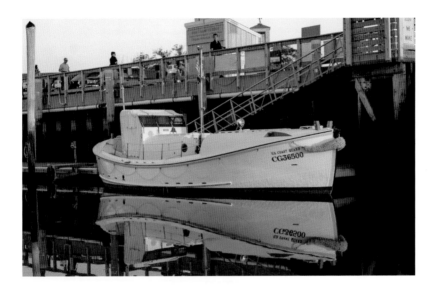

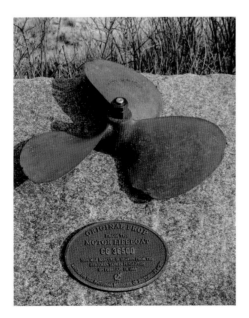

*Above:* The historic CG36500 lifeboat at Rock Harbor.

*Left:* The propeller of the CG36500 lifeboat at Lighthouse Beach.

# 5. Outer Cape

The end of the line on Cape Cod, the Outer Cape includes the towns of Eastham, Wellfleet, Truro, and Provincetown. Buoyed by the Cape Cod National Seashore, this portion of the peninsula hearkens back to what the Cape must have looked and felt like long ago.

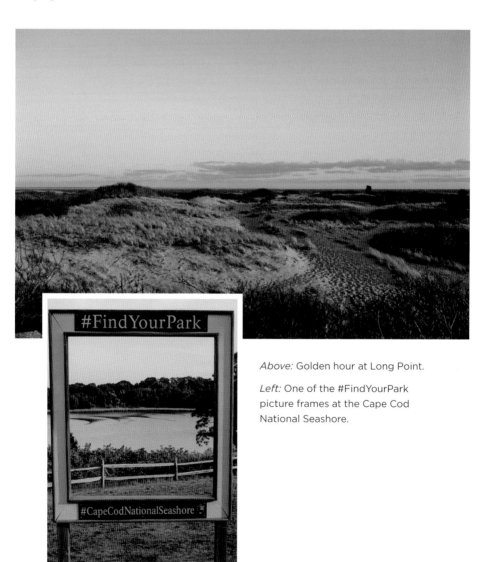

*Above:* Golden hour at Long Point.

*Left:* One of the #FindYourPark picture frames at the Cape Cod National Seashore.

## Three Sisters Lights - Cable Rd, Eastham

In a quiet field sit three diminutive lighthouses. These wooden towers resided at the nearby Nauset Light Beach from their creation in 1892. They got the nickname the "Three Sisters" due to their white towers and black lanterns giving the illusion of being women in white dresses with black hats. Two of the towers were removed from the beach in 1911. The other lighthouse was taken from the beach in 1923. It was replaced by the current Nauset Light in 1923, which was moved to Eastham from Chatham.

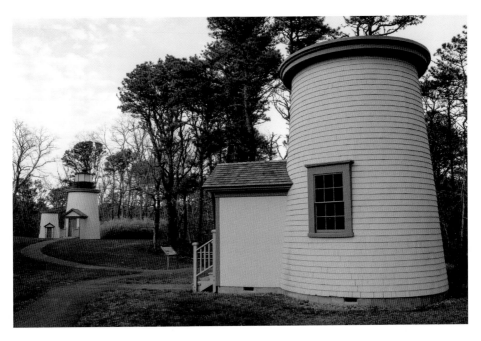

All three of the sisters in Eastham.

## Nauset Lighthouse: 120 Nauset Light Beach Rd., Eastham (*next page*)

This is perhaps the most recognizable of all the Cape Cod lighthouses. Nauset Light adorns all packaging of the popular Cape Cod Potato Chips brand. It currently stands on a hill overlooking appropriately named Nauset Light Beach. The beacon was moved back from the eroding bluffs in 1996. Long before it was a potato chip logo, Nauset Lighthouse resided to the south in Chatham. There it was part of the Chatham Twin Lights until 1923. Then it was decommissioned and moved to Eastham, where it has watched over the Atlantic Ocean for nearly a century.

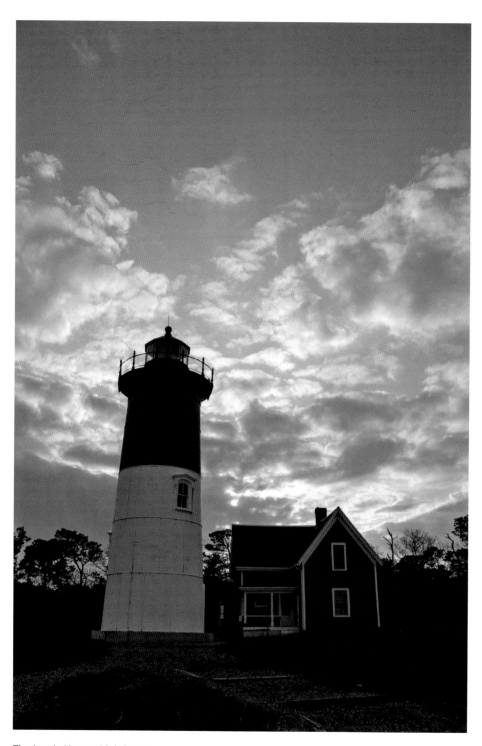

The iconic Nauset Lighthouse.

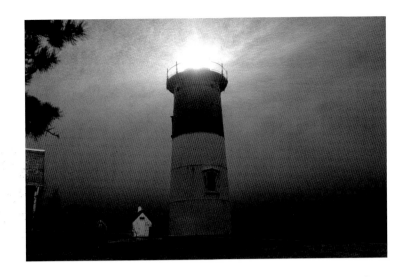

*Left:* Nauset Lighthouse at night during a snow squall.

## Hemenway Landing: Hemenway Rd., Eastham

This secluded waterway is the backside of Nauset Beach. It includes views of the nearby Coast Guard Station and is home to numerous anchored boats in the summer months. A short walk from the parking lot is Indian Rock. This glacial boulder was moved from the encroaching water to the top of Skiff Hill. It has markings showing it was used by Native Americans for sharpening tools long ago.

Calm waters at Hemenway Landing with the Eastham Coast Guard Station in the background.

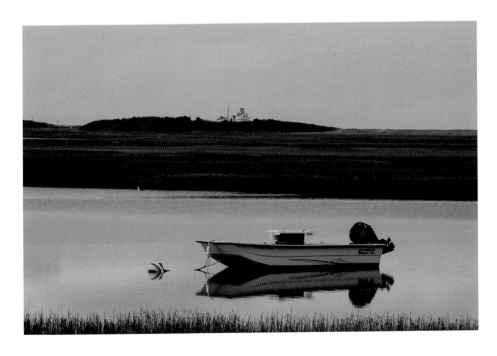

## Christmas Fire Truck: 2520 Rt. 6, Eastham

An annual tradition is this scene of an antique 1946 fire engine decked out in hundreds of colorful Christmas lights. It makes a wonderful photo opportunity, or just a way to bring a smile to the thousands of people who pass by it daily during the holidays.

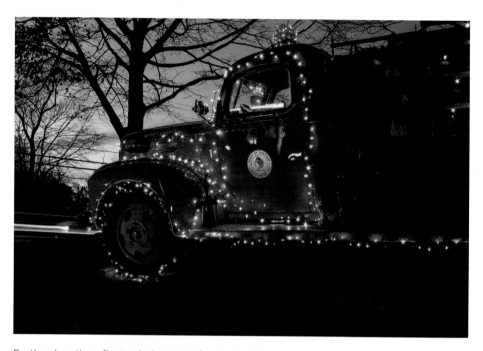

Eastham's antique fire truck decorated for the Holidays.

A close-up of the antique fire truck in Eastham.

### Eastham Xmas Buoy Tree: 2515 Rt. 6, Eastham

Much like the antique decorated fire engine across the street, the town green of Eastham has its own holiday tradition— the beautifully lit buoy Christmas tree. The tree, made of colorful lobster buoys, actually stands year-round. It is a moving tribute to James Filliman, who died in 2018. Filliman built a tree out of buoys in the yard of his nearby Massasoit Road home for the holiday season.

A close-up of the beautifully lit Eastham buoy tree.

### Salt Pond Visitors Center: 50 Nauset Rd., Eastham

The symbolic entrance to the Cape Cod National Seashore. Inside the visitors' center is a gift shop, museum, and theater. Behind the visitors' center is the beautiful Nauset Marsh Trail with scenic views of Salt Pond and Salt Pond Bay (as seen on the next page).

The entrance to the Cape Cod National Seashore in Eastham.

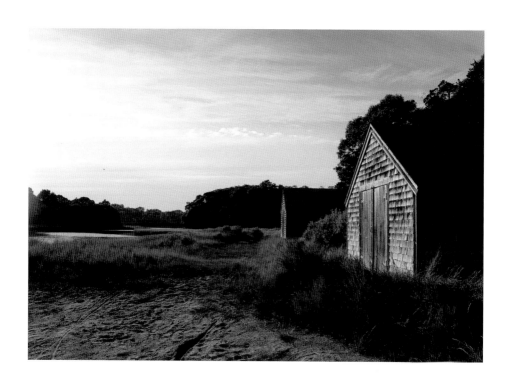

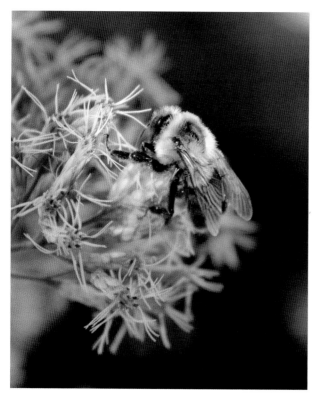

*Above:* Salt Pond in Eastham.

*Left:* A bumblebee along the Nauset Marsh Trail at Salt Pond in Eastham.

## Captain Edward Penniman House: 70 Fort Hill Rd., Eastham

This beautifully colored and uniquely constructed historic home was built in 1868 for the successful whaling captain and his family. The Penniman family lived in the home for nearly a century. The house and the twelve acres it stands on was sold to the National Park Service when the Cape Cod National Seashore was formed.

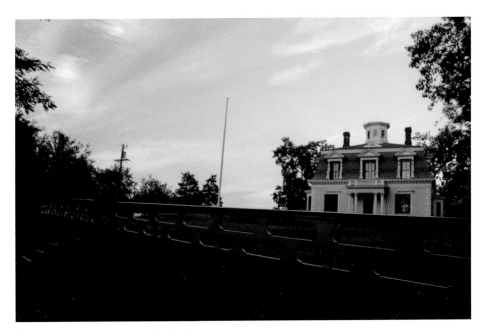

The unique Penniman House in Eastham.

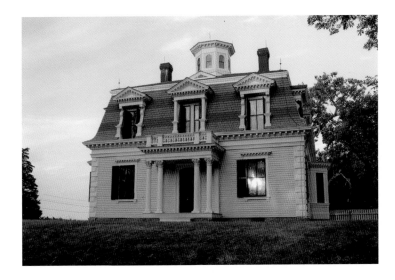

Another view of the Penniman House in Eastham

### Coast Guard Beach: Ocean View Dr., Eastham

It is consistently ranked as one of America's best beaches. Though erosion has ravaged it over the decades, it is still filled with people during the summer months. A satellite parking lot is typically used to shuttle people to the beach, as the small parking lot that remains can only hold a few dozen vehicles. It is a very popular surfing beach.

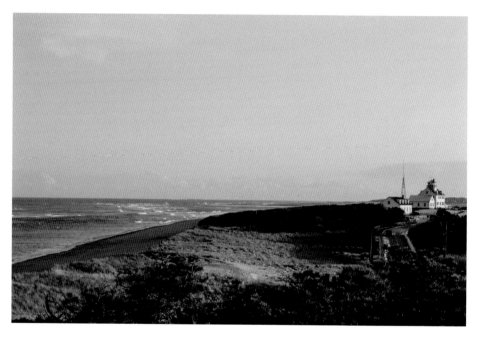

A panoramic view of Coast Guard Beach.

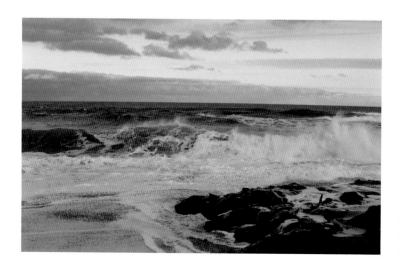

The harsh Atlantic Ocean waves crashing at Coast Guard Beach

## Long Point Lighthouse Provincetown

Twinned with Wood End, this white brick beacon stands at the literal fingertip of the arm that is Cape Cod. It can be reached via boat or after a two-plus mile hike across the West End Breakwater and a long stretch of pristine beach. The current light was built in 1875, though the station was originally established in 1827 when Long Point was home to a thriving community.

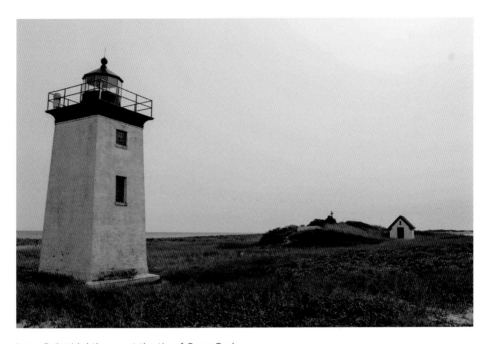

Long Point Lighthouse at the tip of Cape Cod.

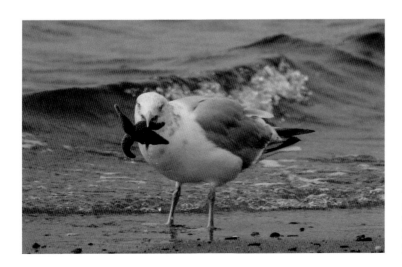

A herring gull grabbing a starfish for lunch at Long Point.

## Wood End Lighthouse Provincetown

Twinned with Long Point, this 39-foot-tall white brick beacon built in 1872 sits in among the desolate dunes across the West End Breakwater. It is the easier of the two lighthouses to reach. Before the creation of the West End Breakwater in 1911, one needed a boat or had to walk nearly a mile and a half south from Herring Cove Beach.

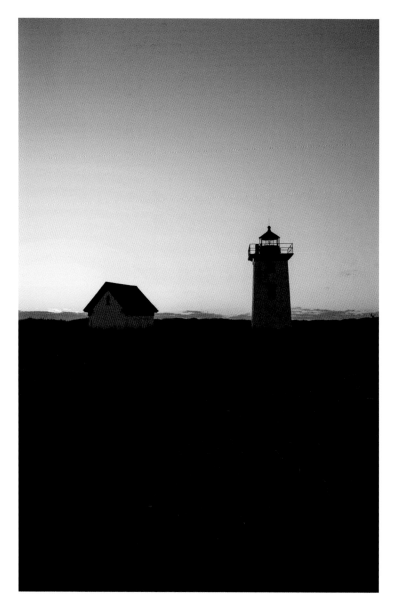

Afterglow at Wood End Lighthouse.

## Hatches Harbor Trail: Province Lands Rd., Provincetown

This beautiful combination of wetland, beach forest, and rolling dunes is an easy way to get lost in how Cape Cod used to be. It passes the Province Lands Bike Trail before heading through scrub pines and out to a sweeping view of Hatches Harbor, Race Point Lighthouse, and Provincetown Airport. Bring ample bug spray in the warmer months.

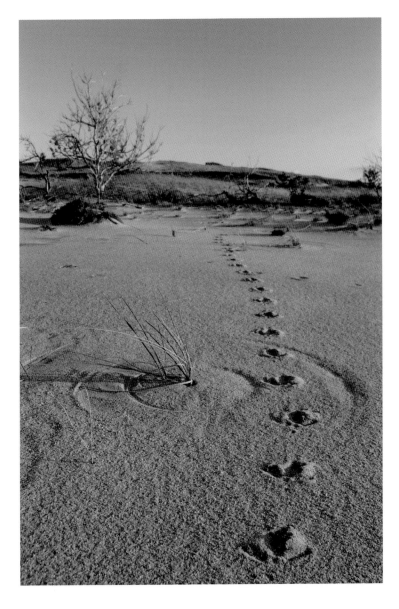

Follow in their footsteps.

### Race Point Lighthouse—Provincetown

Only accessible with an off-road vehicle, or a mile-plus long walk over the sand, this lighthouse has been standing since 1876. The current beacon replaced the original tower built in 1816. Interestingly, Race Point itself is growing in size whereas much of Cape Cod is losing shoreline to erosion. As of 2022, the lighthouse stands more than 400 feet from the ocean.

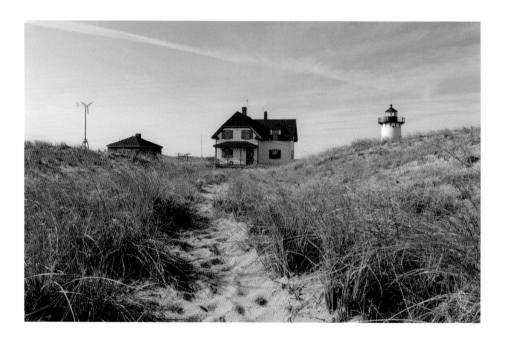

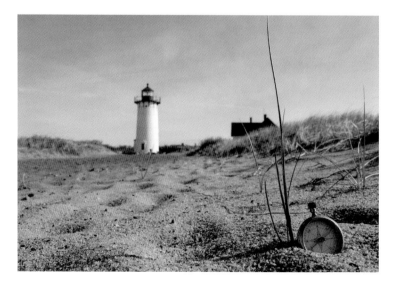

*Above:* A sandy path to Race Point Lighthouse in Provincetown.

*Left:* Follow where your compass leads you.

## Peaked Hill Bars Historic District: Route 6, Provincetown

A walk out over the rolling dunes of Provincetown is akin to a walk back in time. Nineteen rustic dune shacks dot the 1,900-acre historic landscape. Many of them date back to the early twentieth century, beautiful throwbacks to Olde Cape Cod. It is important to remember if venturing out there that many are occupied and to respect their property.

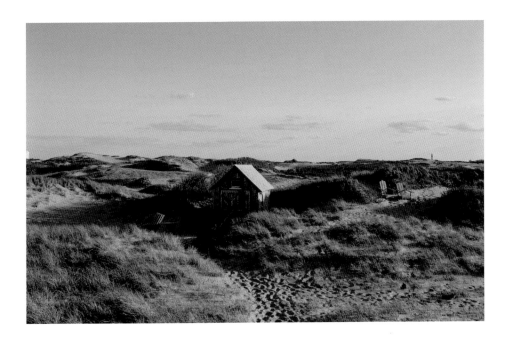

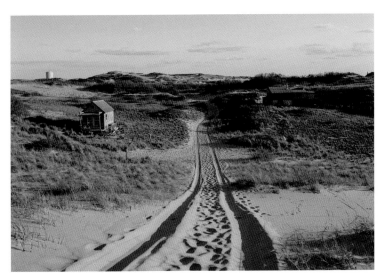

*Above:* A rustic shack in the Provincetown dunes.

*Left:* A few of the dune shacks of the Peaked Hill Bars Historic District.

### Rt. 6 Heading into Provincetown

US Route 6 begins in Bishop, California, and continues east-northeast across America. It travels 3,205 miles until its eastern end in Provincetown, Massachusetts. It was the longest highway in the country from 1936 to 1964 when California renumbered its highways and Route 6 lost some of its length to other routes. Since then, US Route 20, at 3,365 miles, has been the longest highway in the country.

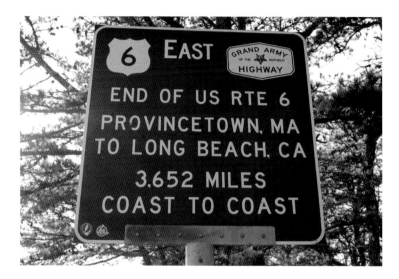

*Left:* A sign marking the end of Route 6.

*Below:* The final stretch of Route 6 in Provincetown.

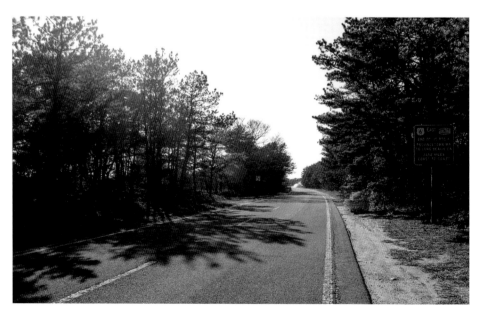

## Long Point – Provincetown

Long Point is a natural formation that appears as the fingertip of Cape Cod. More than 150 years ago, this sandy stretch was a thriving village with a population as high as 200. From 1818 through the mid-1850s, Long Point saw its share of homes, a schoolhouse, salt works, post office, six windmills, and a lighthouse. The failing of the salt works and decline in fishing led many of the villagers to float their homes across Provincetown Harbor and into town. Many of these Long Point "floaters" still stand today and are denoted by a blue and white plaque.

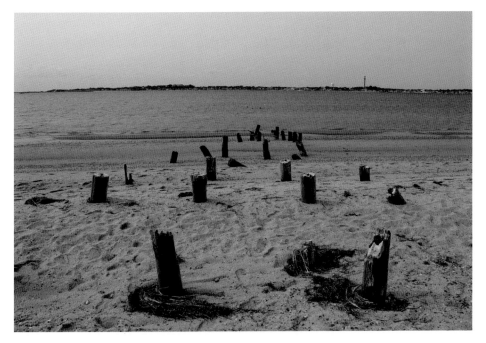

Remnants of the old fish and whale oil works on Long Point in Provincetown.

## Charles Darby Cross – Long Point, Provincetown

Barely visible until in close proximity, this rustic wooden cross celebrates the life and loss of a local war hero. Charles Darby came to Provincetown from Washington, D.C., and was active in the art community. Darby rose to the rank of Staff Sargent in the Air Force during World War II. He died shortly after his transport plane was shot down in 1944.

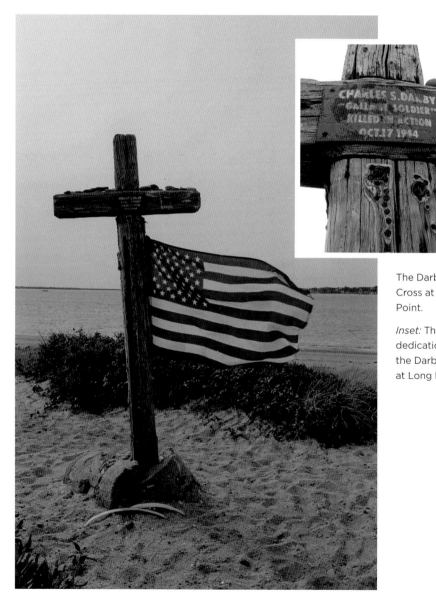

The Darby Cross at Long Point.

*Inset:* The dedication on the Darby Cross at Long Point.

## Flag House: Commercial St., Provincetown

Flag House has become a Cape Cod icon on social media in recent years. Set back from the road, it sits on a wharf that once belonged to Captain Joshua Stickney Nickerson. He also once owned both buildings closer to the road. During the warmer months, the facade of the building is adorned with a large majestic American Flag.

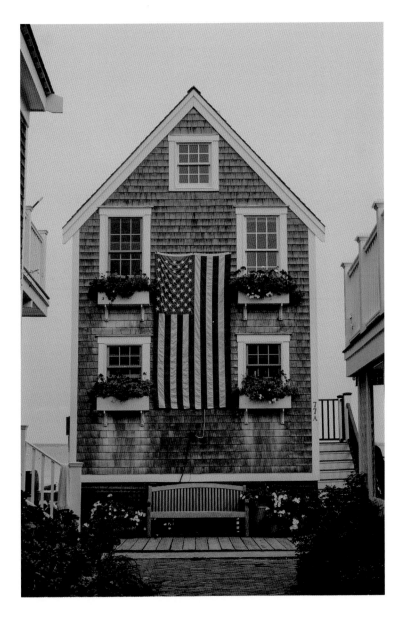

The Flag House on Commercial Street.

### Lady of the Dunes grave: St. Peter's Cemetery, Provincetown

On a hot summer night in July 1974, an unknown woman was murdered and left in the remote dunes near Race Point. Her murder has never been solved and is one of the most enduring mysteries, not only on Cape Cod, but in America. In October 2022 the mysterious 'Lady' was finally identified as Ruth Marie Terry thanks to investigative genealogy DNA testing.

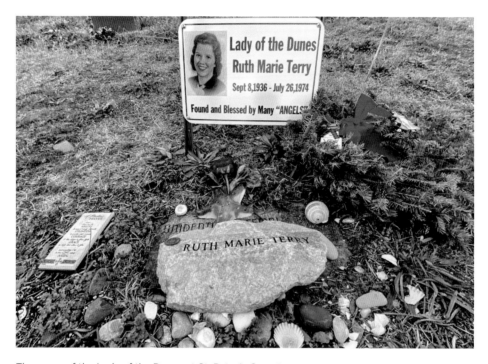

The grave of the Lady of the Dunes at St. Peter's Cemetery.

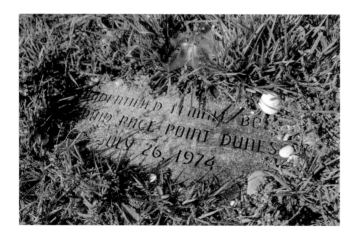

### Old Harbor Life Saving Station: Race Point Beach, Provincetown

This piece of history sits stoically in the dunes near the beach parking lot. For decades, though, it guarded the shores of Chatham. It was built in 1897 and after being decommissioned in 1944, was a private residence for years. The entire building was purchased by the National Park Service in 1977 and subsequently transported by barge to its current resting place.

The Old Harbor Life-Saving Station at Race Point Beach in Provincetown.

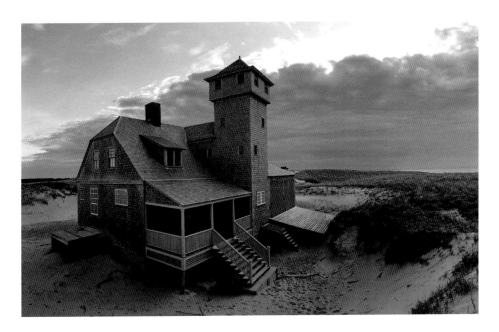

### Provincetown Waterfront (*next page*)

Commercial Street tends to be packed with people during the summer. So much so that it is typically futile to try to drive the street during the season. For those wishing for an escape from the crowds, all one must do is head for the water. Whether beaches, wharves, or breakwaters, there are areas only a few steps off the main road where the views of the town are spectacular.

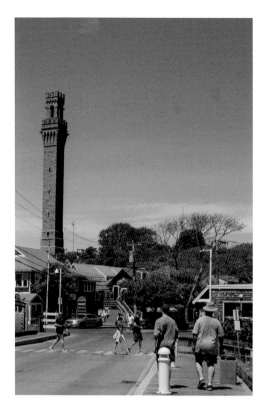

*Left:* The view from MacMillan Wharf in Provincetown.

*Below:* Artist shanties at MacMillan Wharf with a scary guard dog.

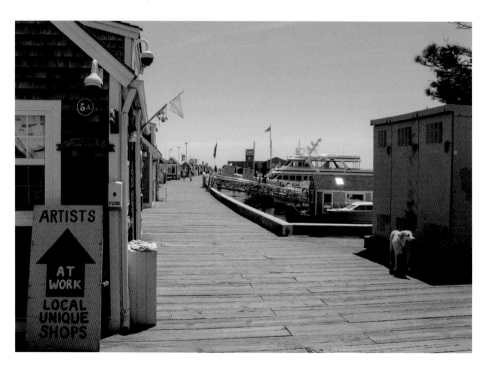

## Crown & Anchor: 247 Commercial St., Provincetown

First opened in 1962, this spot is a cornerstone of gay life in Provincetown. There are six bars and three stages as a part of the complex. Before opening as the Crown & Anchor, it was the Sea Horse Inn in the 1950s. A terrible fire nearly destroyed the property in February 1998. Most recently, the venerable establishment was sold in November 2021 for $7.3 million.

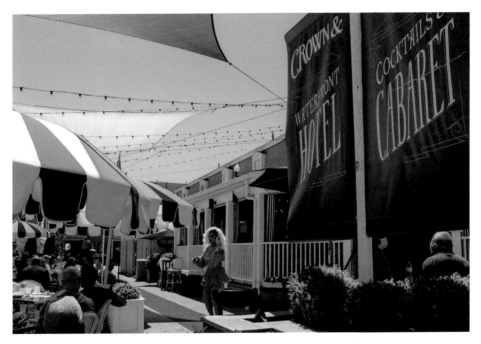

A midday show at the Crown & Anchor.

## Commercial Street, Provincetown

One of the busiest and most popular stretches of road on Cape Cod, Commercial Street is filled with delicious restaurants, unique shops, popular attractions, and actual residential homes. Though a one-way street for vehicles, it is virtually impossible to navigate the crowded Commercial Street during summer.

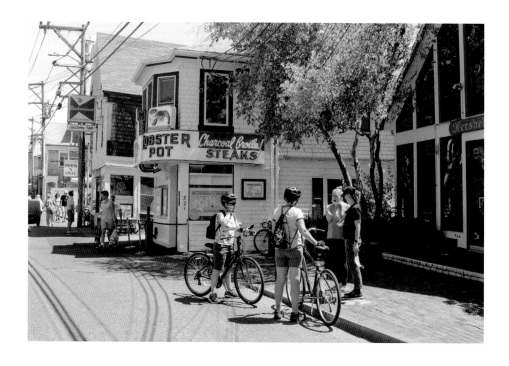

*Above:* The iconic Lobster Pot on Commercial Street.

*Left:* A socially distant pandemic summer day on Commercial Street.

## Pilgrim Monument and Provincetown Museum:
## 1 High Pole Hill Rd., Provincetown

The 252-foot-tall granite monument was built between 1907–1910. Commemorating the Pilgrims' first landing in the New World at Provincetown, it was dedicated by President Taft. A museum was opened the same year of the monument's opening and remains open today. As of 2022, millions of people have climbed the Cape Cod icon and gazed from the top at the wondrous beauty surrounding them.

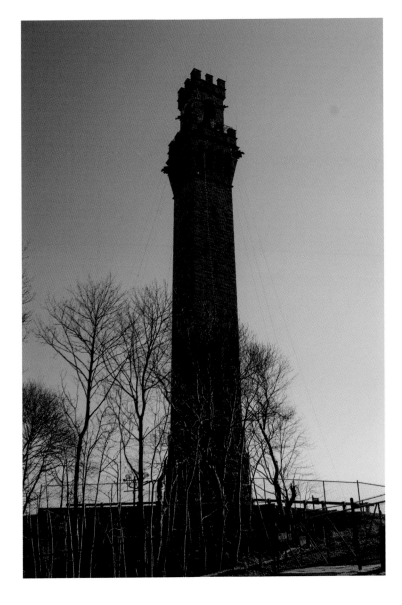

The towering Pilgrim Monument in Provincetown.

## Provincetown Smallpox Cemetery

Located a few hundred yards north of Route 6 in Provincetown, near Shank Painter Road, this cemetery is obscured and overgrown. On its grounds is the final resting places of fourteen people. Half of the eighteen-inch-tall stones are broken. The visible ones have no names, only numbers, which go in ascending order away from the remains of a pestilence house. It is a sad and somber look back at a horrific disease that ravaged the world for centuries. Unfortunately, it is essentially lost to history and nature in the twenty-first century.

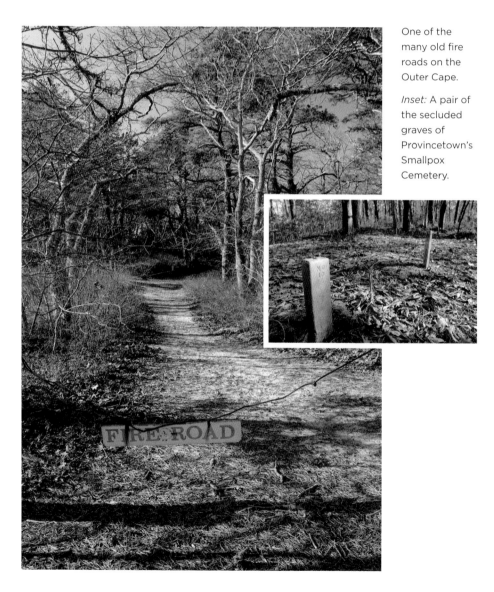

One of the many old fire roads on the Outer Cape.

*Inset:* A pair of the secluded graves of Provincetown's Smallpox Cemetery.

## Highland Light—27 Highland Light Rd, Truro

This is the oldest lighthouse on Cape Cod. It was first established in 1797 with the current structure being built in 1857. It overlooks the Highland Links Golf Course as well as the encroaching bluffs. The lighthouse was moved to its current location in 1996 and underwent extensive renovations in 2021.

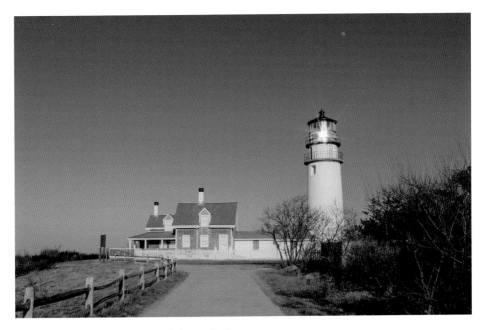

The freshly painted Highland Lighthouse in Truro.

### Days Cottages: 276 Shore Rd., North Truro

These are an iconic collection of twenty-two identical 420-square-foot condominiums. First built in 1931 by Joseph A. Days, they have been part of the beautiful oceanfront scenery on the Outer Cape for nearly a century.

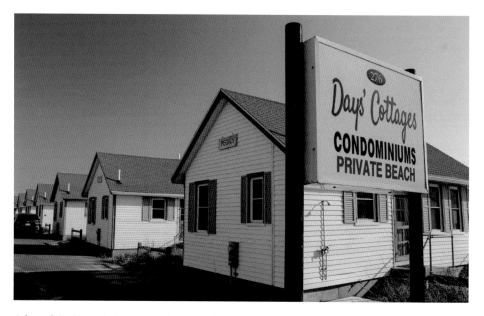

A few of the Days Cottages on Shore Road in North Truro.

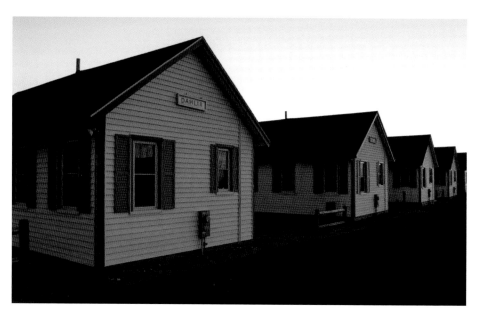

Sunset at the Days Cottages.

### HI-Truro Hostel: 111 North Pamet Rd., Truro

Far off the beaten path, this is a fully operational hostel open between June and September. It is close to Ballston Beach and miles from the center of town. For decades, this building was a rite of passage for local children who could spend a week here for school, learning about Cape Cod ecology through the National Seashore.

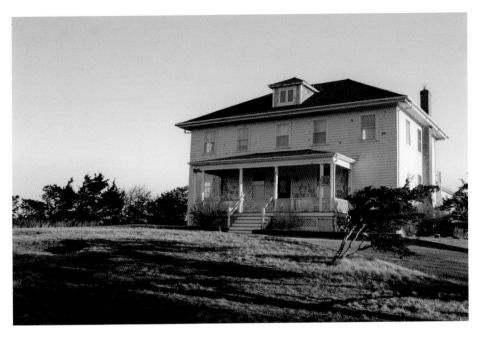

The HI-Truro Hostel in Truro.

### Bearberry Hill: North Pamet Rd., North Truro (*next page*)

The east summit of this spot reaches about sixty feet above sea level. It is high enough to give a sprawling view of the surrounding area, including Ballston Beach. The Pamet Area trails bring you either out to the beach or to the unique Bog House. It is an underappreciated piece of natural beauty and typically quiet even during the height of summer.

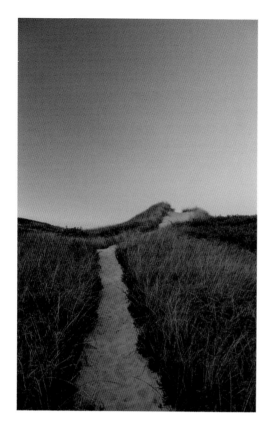

*Left:* The pathway to the beach from Bearberry Hill in Truro.

*Below:* The beach near Bearberry Hill in Truro.

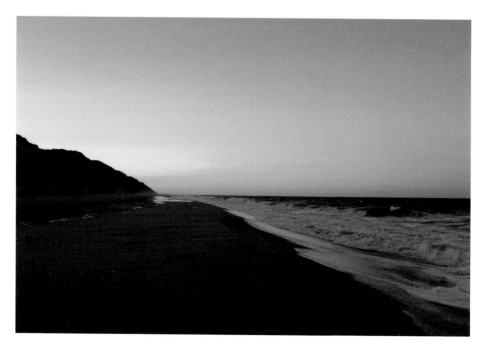

## Bog House: North Pamet Rd., North Truro

Originally built around 1830, this house once stood around thriving cranberry bogs. Cranberry harvesting took place in the Pamet Valley until the 1960s. The house has its front door on the second floor. This is because the house was originally one floor but was raised to create storage space below. Though it is technically within sight of North Pamet Road, it is far more rewarding to take the trail route to reach it.

The uniquely odd-looking Bog House in Truro.

### A Panoramic view of Rt. 6: Truro entering Provincetown

If Cape Cod is shaped like an arm, Truro is the wrist and Provincetown the fist. It is the end of the line not only for Cape Cod but Route 6 as well which begins in Long Beach, California, and travels 3,652 miles to Provincetown. There is a feeling of entering a different world when passing Pilgrim Lake on the right, which in turn becomes a majestic wall of sand dunes.

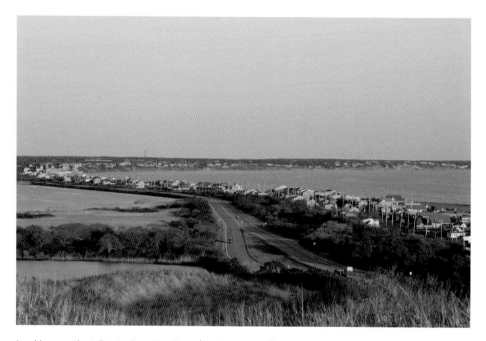

Looking south at Route 6 on the Truro/Provincetown line.

### Pine Grove Cemetery: Old County Rd., Truro (*Opposite*)

This is Truro's second oldest cemetery, and one of the creepiest on Cape Cod. Located truly in the middle of nowhere, it is a half-mile from the nearest road. A connection to notorious serial killer Tony Costa and reports of paranormal activity within the area make this a spooky place only the brave visit after dark.

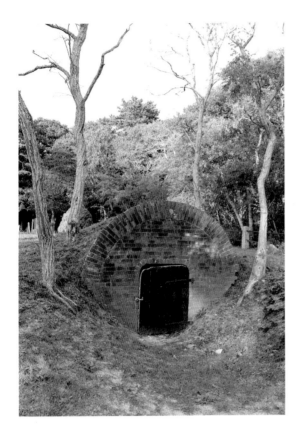

*Left:* The creepy brick crypt at Pine Grove Cemetery.

*Below:* The isolated entrance to the isolated Pine Grove Cemetery.

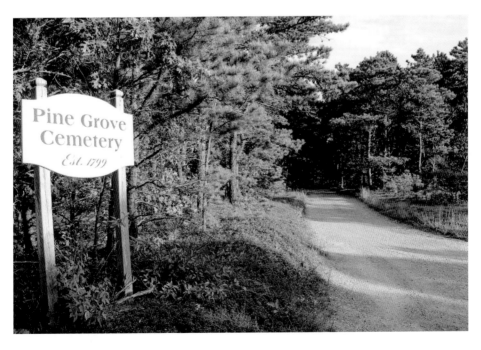

## Thomas Ridley grave: Route 6, Truro

Sad, somber, peaceful, and isolated are all words to describe Cape Cod's loneliest grave. Located more than a half-mile deep in the woods of North Truro sits a single slate gravestone. Once past the civilization of Route 6 and the popular Italian restaurant Montano's, it is nothing but kettle holes and fire roads between a present and past.

Thomas Ridley was an ordinary eighteenth-century man. He contracted and died of smallpox in 1776. Ridley was buried far from the village to avoid passing the deadly virus to others. For more than 240 years, the grave has resided among the brush and scrub pine with few knowing of its existence.

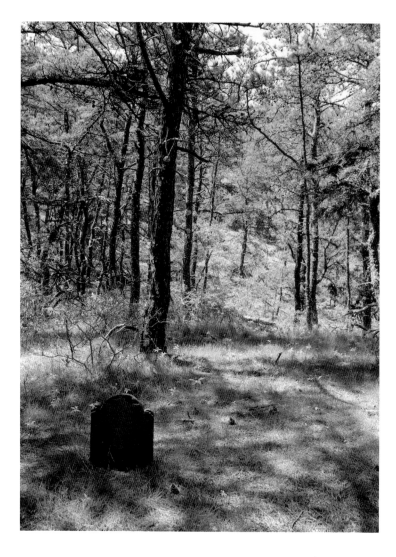

The isolated grave of Thomas Ridley in North Truro.

## Marconi Site: Marconi Station Rd., Wellfleet

On January 18, 1903, Italian Guglielmo Marconi was at the forefront of history. From his wireless station in Wellfleet, the first two-way wireless communication took place between Europe and America. This was a message from United States President Theodore Roosevelt and Britain's King Edward VII. Over the years, erosion had removed nearly all reminders of this once historic site. However, it is possible to stand on the wooden platform and gaze out across the ocean and imagine what it was like to be there on that historic day more than a century ago.

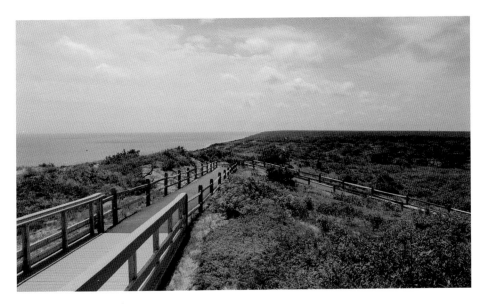

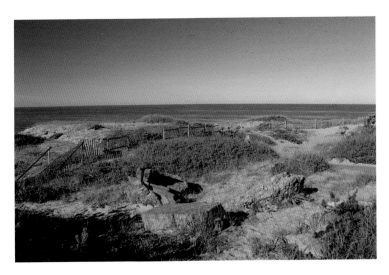

*Above:*
A panoramic view at the Marconi historic site.

*Left:* A few remnants of the old Marconi Site.

### Great Island Wellfleet: Chequessett Neck Rd, Wellfleet

Far off the beaten path, this area is low on phone service but high on natural beauty. The mammoth 8.8-mile Great Island Trail leads you past the historic Samuel Smith Tavern Site and all the way out to Jeremy Point. From there, it is possible to catch a glimpse of Billingsgate Shoal at low tide. The beach along Cape Cod Bay typically sees as many seals as people even during the busiest July. Bring sunscreen, bug spray, and a camera to capture all the amazing scenery of Great Island.

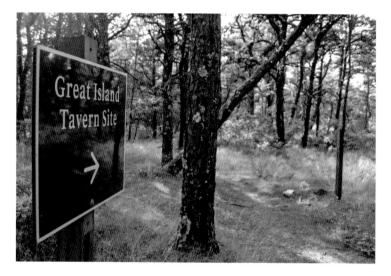

*Left:* The sign for the historic Smith Tavern site in Wellfleet.

*Below:* The beach at Wellfleet's Great Island.

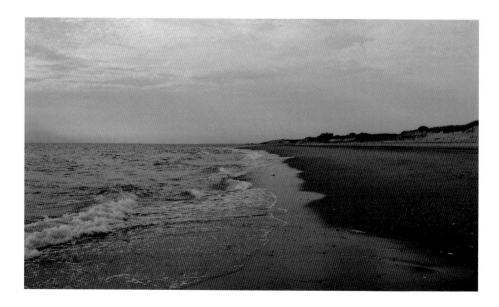

## Wellfleet/Truro Sign

Eclectic art is a part of the fabric of Cape Cod. Uniquely decorated yards, murals, and memorials off the beaten path; and even colorful road signs, are commonplace on the peninsula. Part of the fun of driving along the side streets of Cape Cod is not knowing what you might find. The question is, are you a "Fleetian" or a "Trurite?"

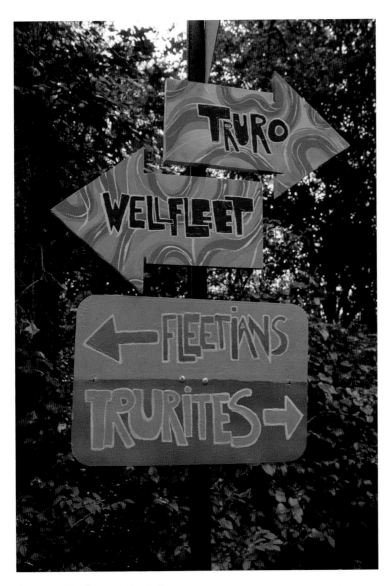

Are you a Fleetian or a Trurite?

# 6. Potpourri

Here are a few of the things that make Cape Cod a unique and wonderful place to live and visit. It includes some of the beautiful wildlife, things to see, places to stay, and sunsets to behold.

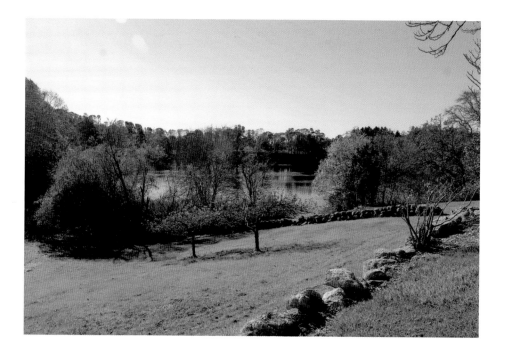

*Above:* A view of Crocker Pond in North Falmouth.

*Left:* A bufflehead duck running across the water.

## Herring Gull

Despite typically being referred to as a "sea gull," this name is a misnomer. Their numbers have grown tremendously over the last century. These birds are seen all over Cape Cod. This bird in particular is a common herring gull. Laughing, ring-billed, and great black-backed gulls are also common to Massachusetts.

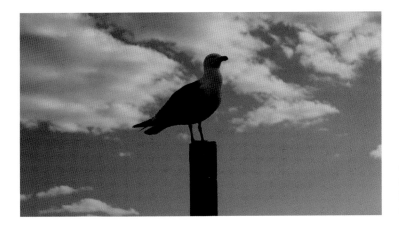

A herring gull on a pedestal at the Cape Cod Canal.

## Willet

This is another common shorebird seen on Cape Cod. Though small, they are fiercely protective of their nesting areas. These birds will swoop at unsuspecting passersby if they feel their nest is threatened.

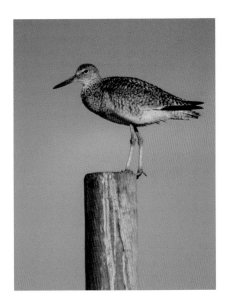

A Willet watching the horizon.

## Red-breasted Merganser

This large-bodied diving duck is spotted regularly on Cape Cod. The male is easily recognized by its deep green colored head. All species have a crest of feathers on its head resembling a Mohawk. They are most commonly seen in the area in late fall and winter.

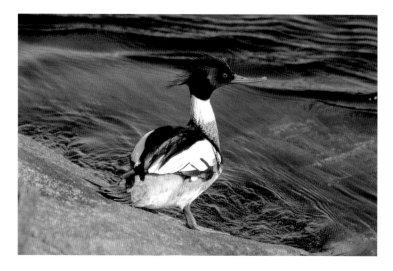

Red-breasted Merganser at Hatches Harbor.

## Red-Tailed Hawk

These predatory birds are common to Cape Cod and most of North America. They can often be seen hovering above the trees, or seated on a telephone pole or branch, searching for their next meal. Their wingspans approach five feet, allowing them to glide or soar into the sky on a thermal updraft.

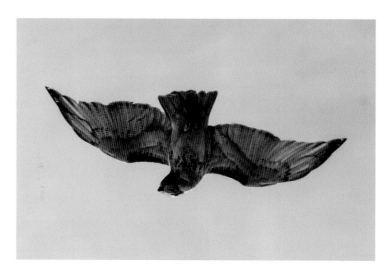

A red-tailed hawk looking for its next meal.

## Piping Plover

Familiar to locals, these once plentiful shorebirds have been classified as "Near Threatened." Through protection, their numbers are increasing. They arrive on Cape Cod in March or April, lay eggs, and raise their young until September before flying south for the winter. Throughout the spring and summer these adorable creatures can be spotted running along the shoreline or hanging out on the beach.

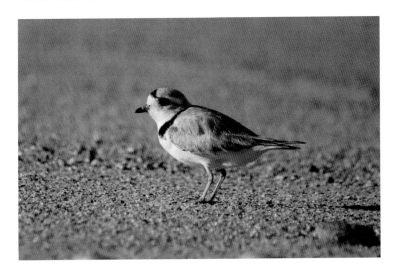

A solitary Piping Plover at Marconi Beach in Wellfleet.

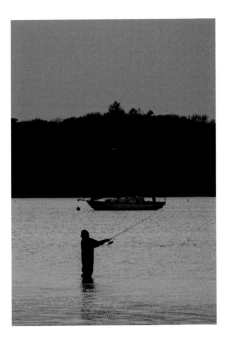

A huge part of work and recreation on Cape Cod is fishing. Whether in shallow inlets, miles out to sea, or casting in local ponds, it is possible to catch anything from striped bass, tuna, cod, and more.

Casting at sunset at Dowses Beach in Osterville.

## Cape Cod's Rail Trails

According to the Cape Cod Chamber of Commerce, there are more than 114 miles of paved bicycle trails on Cape Cod either in existence or in the process of being created, as of 2022. There is little better way to find the heart and soul of Cape Cod than cruising along these wonderful routes. The Cape Cod Rail Trail begins in Yarmouth and currently extends through Wellfleet

The Old Colony trail begins at a rotary in Harwich finishing in Chatham. The Shining Sea Bikeway hugs the coastline between Falmouth and Bourne. The Cape Cod Canal bike trail lines both sides of the man-made waterway between Sandwich and Bourne. Finally, the Province Lands Bike Trail navigates the dunes in Provincetown. All are filled with natural beauty, and all are free to use.

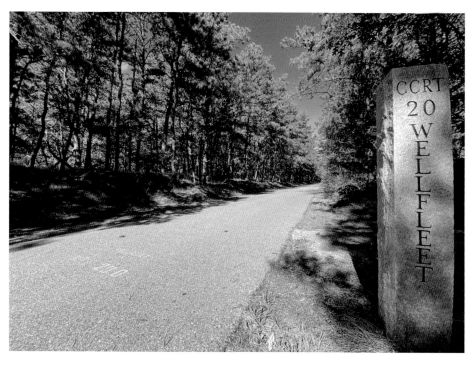

The Cape Cod Rail Trail entering Wellfleet.

The Shining Sea Bikeway.

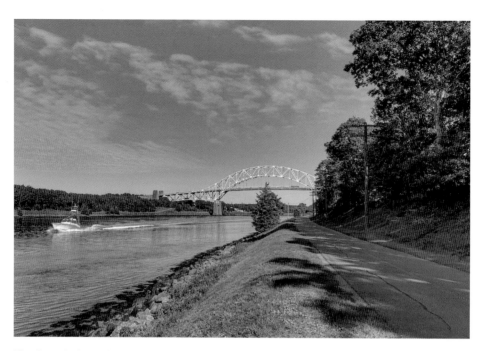

The Cape Cod Canal bike trail.

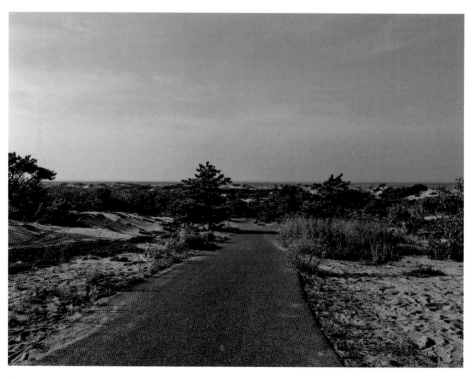

The Province Lands Bike Trail.

# Cape Cod's Bed and Breakfasts

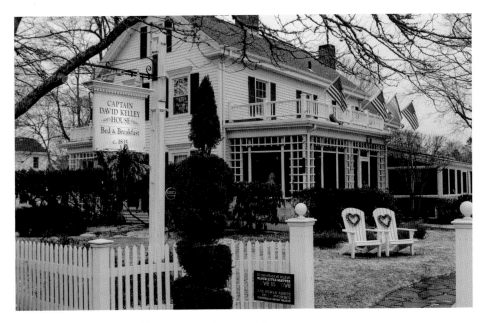

**Capt. David Kelley House (539 Main St., Centerville)**
The David Kelley House bed and breakfast in Centerville.

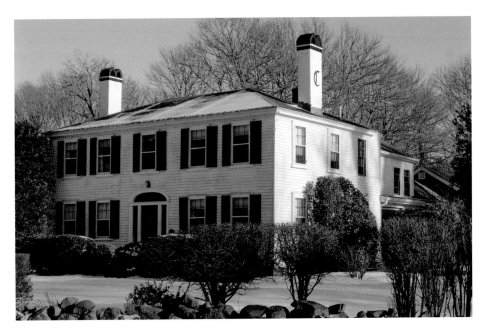

**Candleberry Inn (1882 Main St., Brewster)**
The highly-rated Candleberry Inn bed and breakfast in Brewster.

### A Little Inn on Pleasant Bay (654 Rt. 28, Orleans)

Cape Cod is estimated to be home to more than 250 bed and breakfast establishments. They offer the comforts of home while away. Some of them have unique themes, luxurious amenities, and beautiful locations. These are only a few of the best.

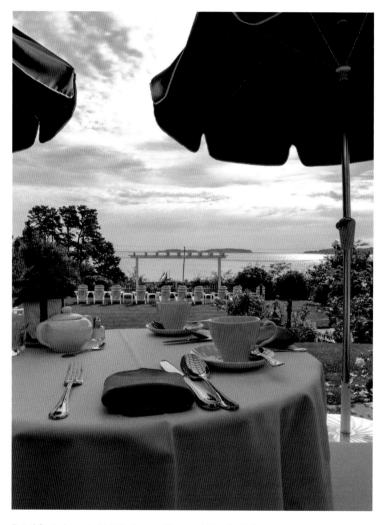

Breakfast view at A Little Inn on Pleasant Bay in Orleans.

## Cape Cod's Spectacular Sunsets

A benefit of being surrounded by water is the ample opportunities to witness spectacular sunsets at any number of gorgeous beaches.

These are but a few of the incredible places to visit on Cape Cod. Above all else, find your own direction and choose your own adventure. Whether it's your first time stepping on the sandy shores, or if your family has lived here for generations, it is possible to fall in love with Cape Cod over and over again.

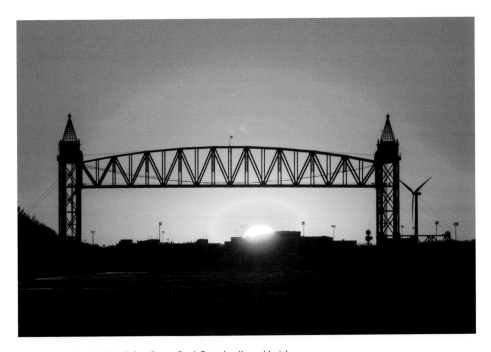

The sun setting behind the Cape Cod Canal railroad bridge.

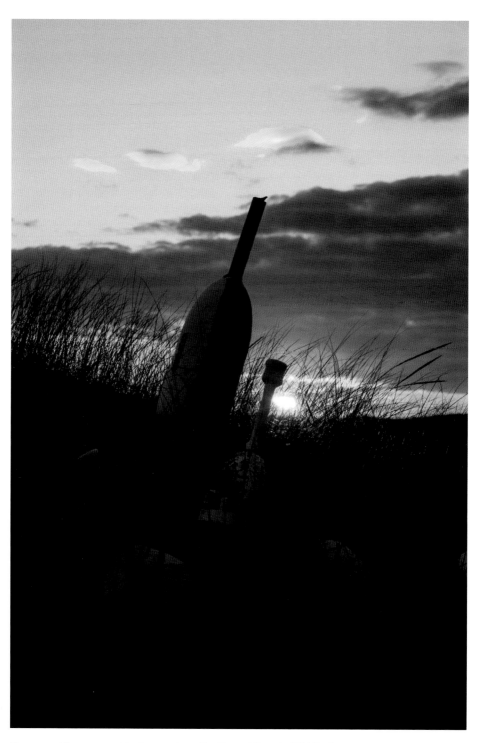

The sun setting among the buoys along the Nauset Beach ORV Trail.

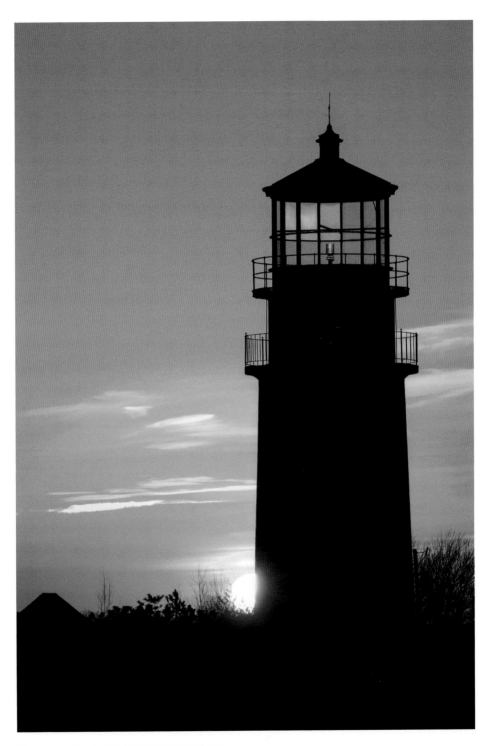

The sun setting behind Highland Lighthouse.

# About the Author

Christopher Setterlund is a proud twelfth-generation Cape Codder and comes from a large family. He has previously written six books. The *In My Footsteps* travel trilogy through Schiffer Publishing and a Cape Cod history trilogy through Arcadia Publishing, which includes *Historic Restaurants of Cape Cod*, *Cape Cod Nights*, and *Iconic Hotels and Motels of Cape Cod*. In addition, he hosts the *In My Footsteps* podcast. Lastly, he is also a certified personal trainer and medical fitness specialist.

*Left:* Author Christopher Setterlund. *Photo courtesy of Steve Drozel*

*Below:* Watching the sunset at Bound Brook Island Beach in Wellfleet.

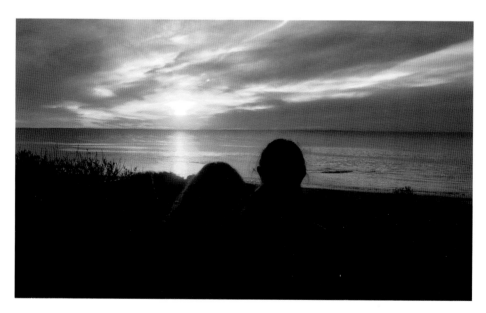